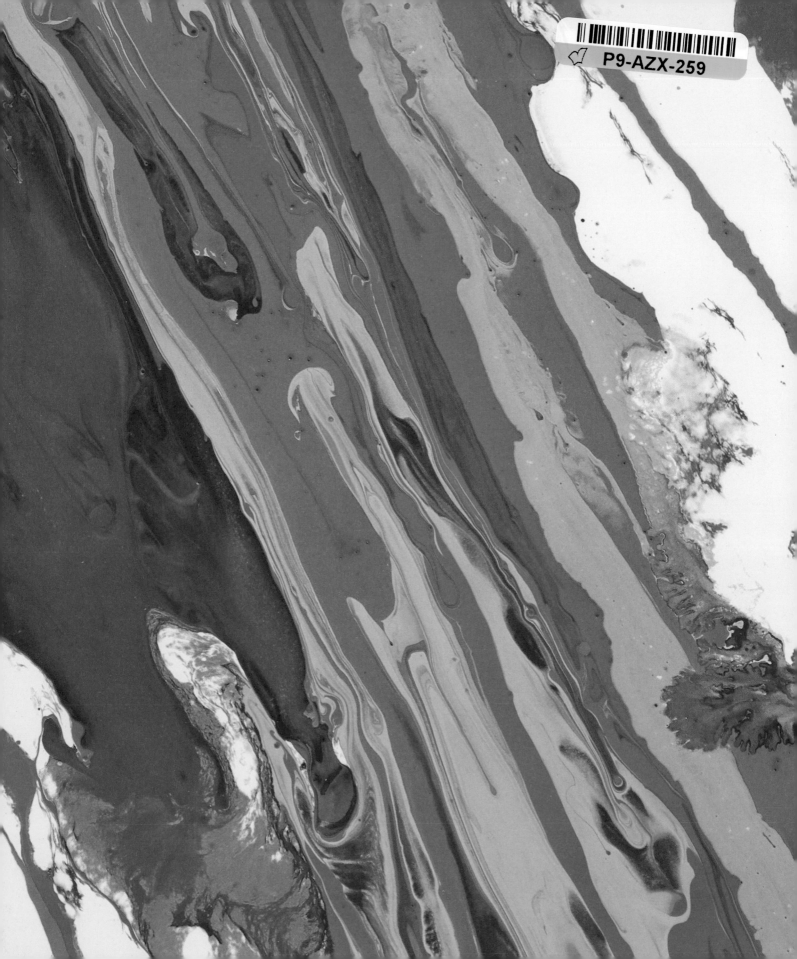

JUST PAINT IT!

Sam Piyasena and Beverly Philp

BARRON'S

A QUARTO BOOK

First edition for North America published in 2014 by
Barron's Educational Series, Inc.

Copyright© 2014 Quarto Inc.

All inquiries should be addressed to:
Barron's Educational Series, Inc.
250 Wireless Boulevard
Hauppauge, New York 11788
www.barronseduc.com

ISBN: 978-0-7641-6654-9

Library of Congress Control Number: 2013951601

QUAR.JPI

Conceived, designed, and produced by:
Quarto Publishing plc
The Old Brewery
6 Blundell Street
London N7 9BH

Senior Editor: Ruth Patrick
Designer: Karin Skånberg
Design Assistant: Kate Bramley
Copy Editor: Liz Jones
Proofreader: Corinne Masciocchi
Indexer: Helen Snaith
Picture Researcher: Sarah Bell
Art Director: Caroline Guest

Creative Director: Moira Clinch
Publisher: Paul Carslake

Color separation in Singapore by PICA Digital Pte. Ltd
Printed in China by 1010 Printing International Ltd

9 8 7 6 5 4 3 2 1

Contents

Materials and Tools
page 10

Form, Light and Shade, and Tone page 30

An Exploration of Color page 50

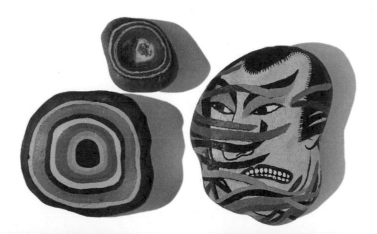

Composition and Space page 80

Pattern and Texture page 98

Observation, Exploration, and Imagination page 114

Foreword

Painting is an innate and primordial activity. The ancient cave paintings of our predecessors serve as a constant reminder of the importance of expressing ourselves through art.

During childhood, our unbridled joy of painting, with or without a brush, is somehow lost as we get older.

In some schools, art has increasingly becoming marginalized in the curriculum and for many children, this lack of practice inevitably leads to a lack of confidence. All the initial excitement and enthusiasm for painting ebbs away.

This book will reignite your passion for painting and will give you the confidence to once again pick up a paintbrush and express yourself.

To begin with, we will focus on paint as a substance and medium in its own right and we will explore various tools and surfaces. You will experiment with new methods that will help to break down any inhibitions that you may have.

You will then use paint to describe form, light, shade, and tone, and will discover

"If you hear a voice within you say 'you cannot paint,' then by all means paint, and that voice will be silenced."
Vincent van Gogh

how to create a sense of three dimensions on a two-dimensional surface.

Next, we will concentrate on the exploration of color in all its forms. Color can be used as a form of personal expression and it can convey emotion, form, depth, and contrast.

Then we will focus on developing an understanding of space. You will view the world from many different perspectives. The exercises included will help you to depict three-dimensional space and create strong compositions. You will then produce a variety of textures and patterns using different mediums and surfaces.

These exercises will enable you to translate pattern and texture through a variety of painting techniques including wax resist, impasto, stippling, and sgraffito.

The final chapter will encourage you to look and think independently and to develop your own creative language. The exercises will help you to expand your creative knowledge and observational skills. You will learn to explore the potential of this versatile and truly exciting medium.

Sam Piyasena and Beverly Philp

CHAPTER

Materials and Tools

"I use all sorts of things to work with: old brooms, old sweaters, and all kinds of peculiar tools and materials."

Francis Bacon

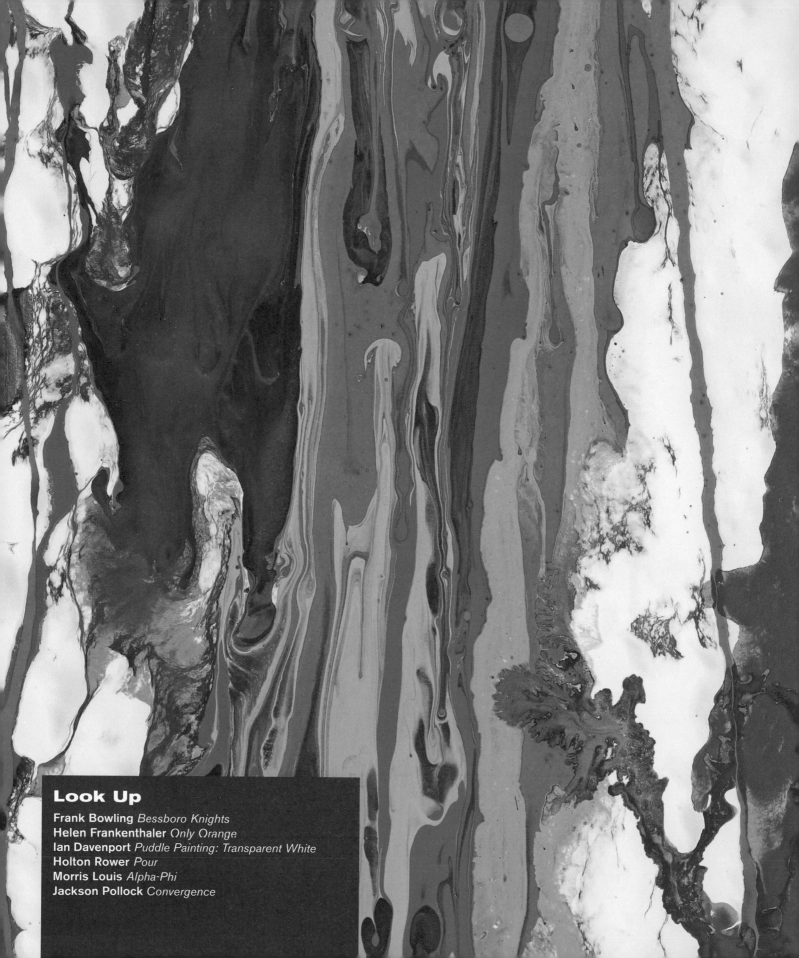

Look Up

Frank Bowling *Bessboro Knights*
Helen Frankenthaler *Only Orange*
Ian Davenport *Puddle Painting: Transparent White*
Holton Rower *Pour*
Morris Louis *Alpha-Phi*
Jackson Pollock *Convergence*

Downpour

To fully understand how to use and apply paint, we have to understand its fundamental properties and characteristics. Here we are going to explore paint's viscosity (thickness). Think of paint as if it were a batter mixture. The thickness of acrylic paint, for example, can be modified using water or a variety of gels, mediums, and pastes. The viscosity of oil paint can be altered using linseed oil (and other oils), or solvents such as turpentine or mineral spirits.

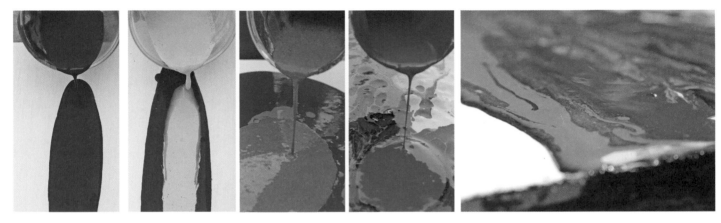

"… everyone was sort of pouring, staining, dripping, whatever."

Frank Bowling

Guyana-born artist Frank Bowling (b. 1936) creates paintings by pouring paint onto large canvases. He designed a custom-built platform that can be tilted and manipulated to create these "poured paintings." By carefully tipping his canvas he allows the paint to run freely down the surface. Using a combination of control and serendipity, Bowling attempts to direct the flow of the paint. The viscosity of the paint is a key factor in determining the speed and directional flow. The layers of thick paint spill and pool on the surface to create a wonderful confluence of colors, textures, and patterns.

Method

1. For this exercise you are going to carry out an experiment with paint. You will need a selection of different-colored acrylic paints, and plastic sheeting to protect the surrounding area. Find some cups or pitchers—anything that you can easily mix up paint in and pour it from. Plastic party cups are ideal.

2. Mix up about four or five different-colored acrylic paints in separate cups. You can dilute the paint with water or add a pouring medium. (Acrylic paint manufacturers produce pouring mediums to control the liquidity of the paint.) You are aiming for a runny, but not-too-watery, consistency.

3. Find a suitable surface to pour your paint onto. A large, flat board or canvas would be perfect. Coat the board with a primer to help the paint adhere to the surface. Tilt the board at a gradient of no more than 60 degrees.

4. Begin to pour your first color from the top of the board and let it flow freely down.

5. Now pour another color from the top and into the first color.

6. Continue to pour other colors from the top and at different points on the board and watch them flow, swirl, and merge together.

7. You can tilt the board up and down to further manipulate the paint. The results will be unpredictable, but it is a strangely satisfying experience.

In the Thick of It

Impasto is an Italian term that refers to the application of thick layers of paint onto a surface. Paintings made using this technique have textured and three-dimensional effects.

Frank Auerbach (b. 1931) is a Jewish, German-born, British painter who is one of the leading exponents of the impasto technique. For the last fifty years he has rarely ventured out of North London, where he lives and works. He works obsessively and spends most nights of the week sleeping in his studio. He once said, "It seems to me madness to wake up in the morning and do something other than paint, considering that one may not wake up the following morning." His subject matter is confined to street scenes of his neighborhood and portraits of a select group of sitters, some of whom he has painted over a number of decades.

Auerbach applies layer after layer of thick paint, often scraping them back and then repainting, until the canvas is heavy with texture. These paintings can take months, sometimes years to finish, but still manage to retain an energy and spontaneity.

You are going to paint a figure using the impasto technique. If you have ever modeled for someone, you will know how hard it can be to hold a pose. To make things easier for your model, you are going to paint them comfortably seated. It is better still if they are occupied by watching TV, reading a book, or even sleeping. It'll be much easier to reposition your sitter for another session if they are sitting naturally. The most challenging aspect of this exercise is to capture your model's relaxed posture using energetic and spontaneous strokes. Position your model so you can see their full body. A seated figure can look odd if you don't include at least a suggestion of what they are sitting on, and sometimes the surrounding area.

Look Up

Frank Auerbach *J.Y.M. Seated, Half-Length Nude*
Chaim Soutine *Girl in Green*
Anselm Kiefer *Nuremberg*
Willem de Kooning *Woman V*
Lucien Freud *Reflection, Self-Portrait*
Leon Kossoff *Cathy No. 1, Summer, Two Seated Figures No. 2*

See Also:
Have Your Cake and Paint It, pages 132–133

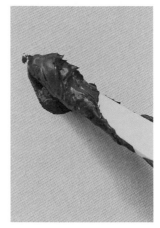

The artist applies a thick splodge of Payne's Gray to the canvas.

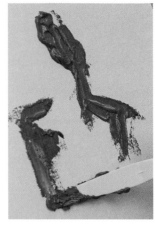

Here they begin to spread the oil paint liberally over the canvas with a palette knife.

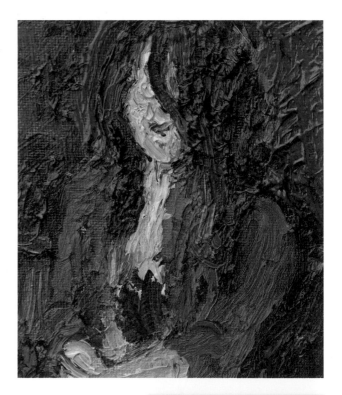

Gradually the artist builds up the layers of paint and concentrates on the detail of the face.

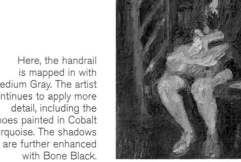

Here, the handrail is mapped in with Medium Gray. The artist continues to apply more detail, including the shoes painted in Cobalt Turquoise. The shadows are further enhanced with Bone Black.

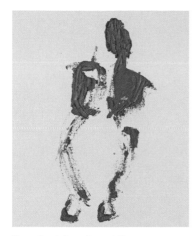

The oil paint marks out the proportion and weight distribution of the figure.

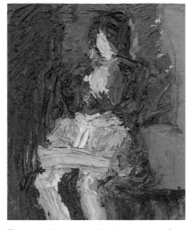

The artist begins to block in areas of color: Cadmium Red, Yellow Ocher, Cadmium Yellow, and Phthalo Green.

A mixture of flesh tones is applied to define the face, arms, and legs of the figure.

Method

1. Use a primed canvas or canvas board with oils and palette knives. Don't skimp on paint. If you want you can thicken your paints by using an impasto medium.

2. Study your figure and observe the weight distribution of their body. Where is the position of the head and shoulders—are they tilting? Where are the arms and legs falling? Take a thick amount of oil paint onto your knife and begin to mark out your composition onto the canvas board.

3. Apply your paint, making bold gestural marks. Build up the structure and almost sculpt the figure in paint.

4. Like Auerbach, you can scrape the paint away and re-layer until you are satisfied.

In the final painting, a raw, textural effect is created by gradually building up the background with thick, impasto paint and also scraping away at the surface. The artist continues to layer the mixture of flesh tones and adds details to the features on the face.

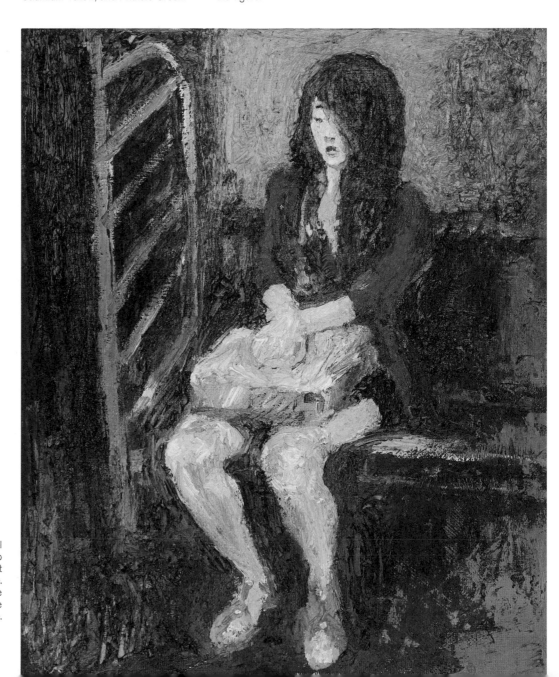

The English artist John Constable (1776–1837) painted many of his preparatory oil sketches outdoors in the Suffolk countryside. In France, the Barbizon School of artists who were inspired by Constable made paintings outdoors in the Forest of Fontainebleau. One of the Barbizon artists, Theodore Rousseau, so loved painting in the forest that he wasn't even deterred by the freezing temperatures of winter.

A few years later, it was the French Impressionist painter Claude Monet (1840–1926) who really put *en plein air* painting on the map; he became its leading exponent. The landscape painter Eugène Boudin had first encouraged the young Monet to paint outdoors. The two went on a painting trip to Rouelles in northeastern France that completely changed Monet's outlook on art. "Gradually my eyes were opened and I understood nature," he proclaimed.

Method

1. There's nothing worse than being stuck indoors on a hot summer's day. So grab a watercolor box and pad, put your shades on, and hit the beach.

2. Lay your towel down on a crowded beach—in fact the more crowded the better, as this exercise involves you painting the people around you and this will give you a wider choice of subjects.

3. The joy of beach painting is capturing people at their most relaxed. Think kids playing, sunbathers, surfers, people reading, couples canoodling, and even those pot-bellied men squeezed into their tiny bathing suits!

4. It's best to use a small pad and a limited palette of colors. Avoid painting with sea water, as you might be left with white salt marks on your page. However, this can also be used as an effect—it works best with dark colors.

5. Paint quickly, making swift gestural marks. Don't be too meticulous—if a painting isn't working, either start again or move on to another subject.

6. Finally, be sensitive to the fact that people are practically naked, so don't gawk!

Let's Go Outside

Traditionally, artists had to make their own paints by laboriously mixing pigments and oils. The invention of squeezable metal tubes of paint and the portable easel in the nineteenth century gave artists the freedom to paint *en plein air* (in the open air). Before this, most artists painted in their studios from sketches and color studies made out-of-doors.

Look Up

Monet *Impression, Sunrise*
Paul Cézanne *The Bathers*
Peter Blake *Have a Nice Day, Mr Hockney*
Marlena Dumas *The Painter*
David Austen *Untitled (Woman on Man's Shoulders)*
Hernan Bas *Apollo with Daphne as a Boy*
Henri Matisse *Bathers with a Turtle*
Georges Seurat *Bathers at Asnières*

Paint Ball

Here we are going to let chance take its course—we are going to be spontaneous and let go. This exercise will help liberate your approach to paint as a medium and it will also inspire you to experiment with unfamiliar techniques, materials, and tools.

Look Up

Shozo Shimamoto *Palazzo Ducale 27*
Jiro Yoshihara *Blue Calligraphic Lines on Dark Blue*
Niki de Saint Phalle *Tirs*
Yves Klein *Anthropometry ANT 85*
Jackson Pollock *Convergence*

In 1954 postwar Japan, a group of artists formed the highly influential "Gutai Group." The group was a collective of experimental Japanese artists whose aim was to focus on materials and the creative process, as much as the finished work itself. The founder of the group, Jiro Yoshihara (1905–1972), urged the Gutai artists to explore innovative and fresh approaches to art: "Do what no one has done before," he proclaimed. One of the members of the group, Shozo Shimamoto (1928–2013), believed in liberating color from the paintbrush and implored artists to throw their brushes away in an article called "Killing the Paintbrush." He wanted to redefine the practice of painting and was interested in the element of chance and spontaneous action in his work. In 1956, he loaded glass bottles filled with paint into a cannon and fired them at a canvas, to create explosions of color. "Even if my method seems shocking and violent—crushing

"It is only once the paintbrush has been discarded that the paint can be revived."
Shozo Shimamoto, from his article "Killing the Paintbrush"

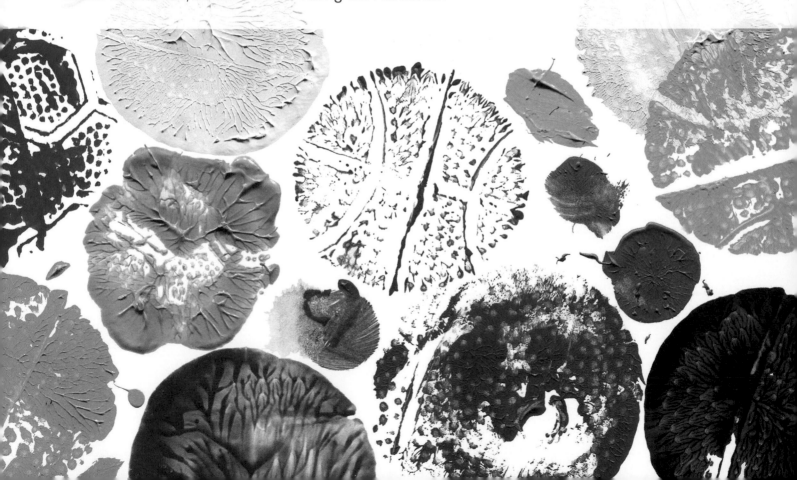

bottles and shooting cannons at the canvas—because I am an artist my purpose is to make the work beautiful, to show the beauty of everything."

In the early 1960s, the French artist Niki de Saint Phalle (1930–2002) began a series of "Shooting Paintings." She filled plastic bags with colored paint and hung them on a board and then completely covered them with plaster. Using a rifle, she then shot the bags to release the paint. "It was an amazing feeling shooting at a painting and watching it transform itself into a new being," she said.

Method

1. Find a selection of balls—preferably tennis ball-sized and nothing so heavy that it will make holes in your paper. Stick a large sheet of paper onto a wall or lay it out flat on the floor. Unless you have a large studio space, it's best to make this painting outdoors.

2. Use acrylic paints for this exercise and apply one color at a time to a ball. Using a paintbrush, coat the ball with a thick layer of paint. This is a messy business, so be prepared to get your hands dirty.

3. Ready. Take aim. Fire! Throw the ball directly at the paper. You can vary the speed at which you throw the ball. The intensity of the paint will fade the more you use the ball. Now repeat with a different-colored ball. Continue to throw and build up colors and patterns on the paper.

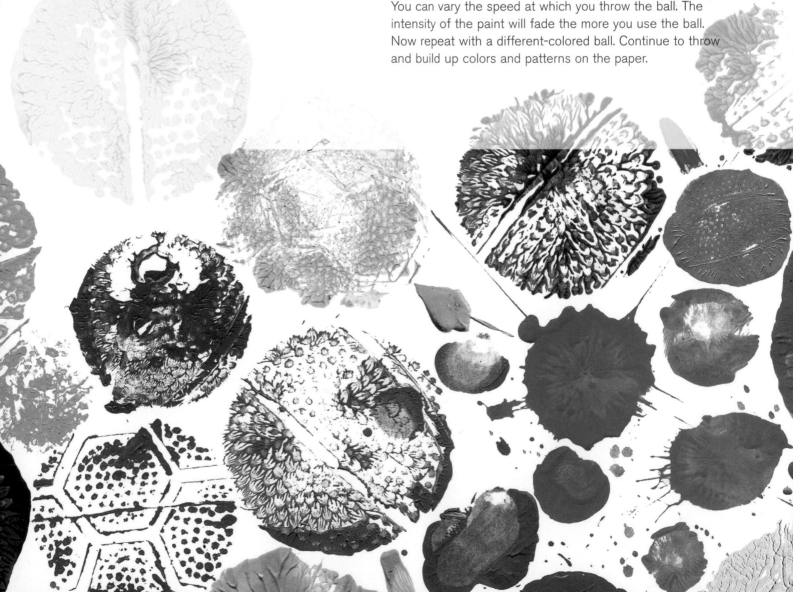

*"… water is the driver of nature
… without it, nothing retains its form."*
Leonardo da Vinci

Float On

Suminagashi **means "floating ink"
and is the ancient Japanese art of
painting onto water. This marbling
technique was originally practiced
by Japanese Shinto priests in the
twelfth century. The water-resistant
sumi-e inks are dropped onto the
surface of water and manipulated to
create patterns. The paintings are
then lifted gently from the surface
of the water by laying rice paper
over them.**

The contemporary waterpainting artist
Amy Lee Segami has taken inspiration
from the ancient Suminagashi masters.
She has a scientific background in
mechanical engineering and believes
that her work is a fusion of science
and art. She manipulates the liquid
viscosity of the water and studies
its movement to dictate the direction
of her paint. She believes that her
paintings are also a collaboration with
nature: "My brush and my hand, the
water and the paint, the environment
and my body, all become one."

Method

1. You are going to make your
own paintings on water. Mix several
colors of oil paint with a small amount
of turpentine until they are the
consistency of heavy cream.

2. Fill a shallow tray with water at room
temperature (1–2 in./2.5–5 cm deep).

3. Drop a small amount of the color
onto the surface. If the color sinks to
the bottom it is too thick; if it dissolves
on the surface, it is too thin. It may
take time to achieve a perfect balance.

4. When the paint is the right
consistency, drop spots of color with
the tip of a stick or brush (one for each
color) onto the surface of the water.

5. Play with the paint on the surface of
the water, making a variety of patterns
and shapes. You can drag the paint
gently into various swirls and spirals.
You can also use a variety of tools
such as feathers, combs, brushes,

Look Up

Amy Lee Segami *Memory of China*
Yücel Dönmez *Millennium Stamp 2*
Leonardo da Vinci *Studies of Water Passings Obstacles and
 Falling*

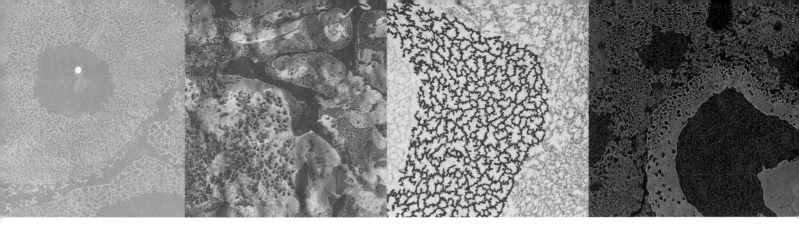

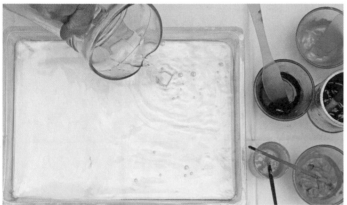

A shallow tray is filled with water at room temperature.

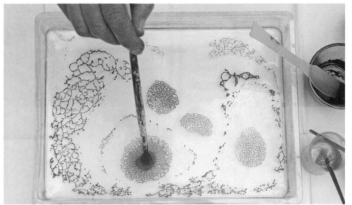

A spot of red paint is carefully dropped onto the surface with the end of a paintbrush.

needles, and sticks to manipulate the paint.

6. You could make a movie or take a series of photographs of the patterns created by the paint in motion.

7. Cut sheets of paper to fit in the tray. Experiment with different qualities and colors of paper. The paper should be thick enough so as not to dissolve in the water. The best results will generally be with more absorbent papers. Paint will adhere more easily to paper that has less size (glue). Office paper, watercolor paper, and rice paper are all examples of absorbent papers that will give good results.

8. Lower the paper gently into the water so that the entire sheet is floating on the surface.

9. Then, gently lift the paper from the water and place it flat on its back to dry.

10. If you want to experiment further, you can use carragheen (seaweed) or other gelatinous chemicals as surfactants. You can also use acrylic paint as an alternative to inks and oils. It's a question of creating the right balance of water viscosity and consistency of paint.

11. This is a great exercise to help develop your imagination.

Invisible Ink

This exercise will help you experiment with one of the oldest forms of painting using ink: *Yu pi yo mo* ("to have brush, to have ink"). Chinese brush painting began around 4000 BC.

This is a yin-yang painting; a simple response to your subject using invisible ink and applying it directly onto the page. It will heighten your observational skills and enhance the thinking and seeing process. You will explore exactly how to apply the brush to the paper.

Don't finesse or try to capture detail.

Don't worry about going over lines drawn.

You want an impression, even if it doesn't flatter.

Look Up

Rembrandt van Rijn *Young Woman Sleeping*
Hsieh Ho *Six Canons of Painting*
Xu Beihong *Horses*

EMPIRE

Ink Recipe
1 tsp. baking soda
2 tbsp. water

Method
1. Take a brush, and using the solution above, look closely at your subject and respond directly onto the page. Apply the brushstrokes in a fluid way. You are not trying to faithfully reproduce your subject but to depict its character and essence.

2. When you feel that your image is complete, leave the ink to dry.

3. Heat the oven to 300°F/150°C/ Gas Mark 2.

4. Place the paper in the oven and bake for approximately 10–15 minutes.

5. Take out your paper and look at the image now fully formed in front of you. A chemical reaction with the acid-based ink will reveal all.

6. As alternative "inks" you could try white wine, lemon juice, apple juice, or orange juice.

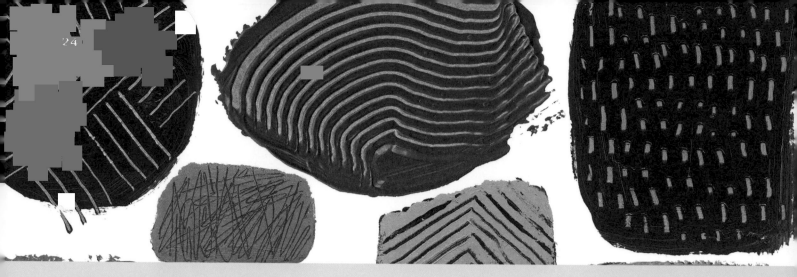

Artists have often taken great pleasure in not only applying paint to the surface, but also scraping it away and removing it. In the sixteenth century in Italy, for example, a decorative wall painting technique known as sgraffito (from the Italian word that means "to scratch") was extremely popular. The technique traditionally involved layering color onto the plaster of a wall or ceramic surface, and then scratching into the surface with a sharp instrument to expose the underlayer of color.

"Experimentation is key. There are the constants of surface and tool, but the variations within those anchors are limitless."
Julia Dault

Scratch

Sgraffito techniques have inspired painters such as the Catalan artist Antoni Tàpies (1923–2012), who was captivated by the defaced and textured walls of Barcelona. He applied various materials to his "matter paintings," scratching into the surface to create incisions that emulated the textures and marks of the walls.

The Canadian artist Julia Dault (b. 1977) uses an unconventional combination of implements and materials. She creates scratch paintings with tools such as squeegees, combs, industrial door handles, and tree branches. Her surfaces are also varied, and include canvas, vinyl, spandex, and pleather (fake plastic leather). The swirls and curves of paint are manipulated with sweeping gestural movements. The top layer of paint is scored away using her improvised scraping tools to create marks and patterns, revealing areas of color beneath. Dault believes that her work is an "experimental practice," and she relishes the element of serendipity.

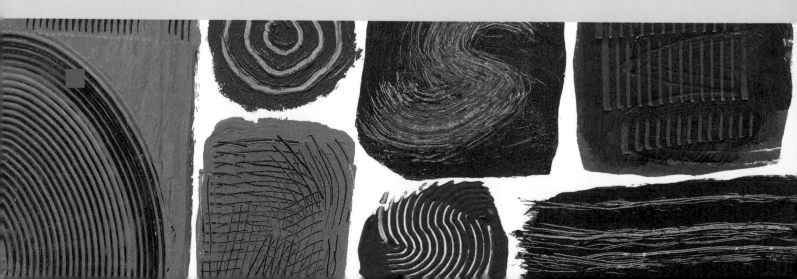

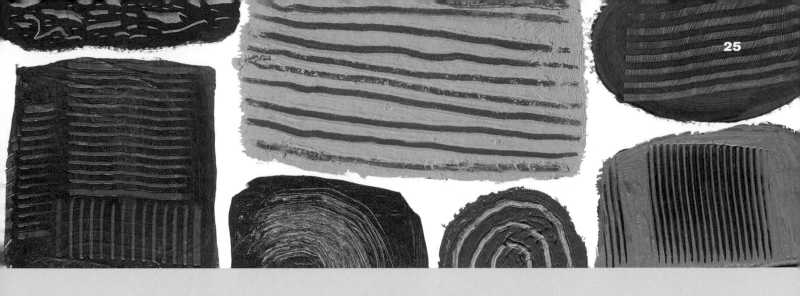

Method

This is your chance to explore and investigate a number of scratching tools to create a variety of textures and marks.

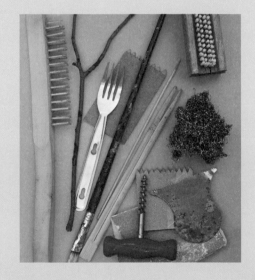

1. Find a collection of tools to create interesting marks. For example:
- ★ a fork or knife
- ★ the end of a paintbrush
- ★ a decorator's glue spreader
- ★ sandpaper
- ★ combs
- ★ a toothpick
- ★ chopsticks
- ★ a knitting needle
- ★ steel wool
- ★ a twig
- ★ a scalpel
- ★ a utility knife

2. Don't scratch too vigorously on a stretched canvas or paper, or it will rip. You can show less restraint if you are using canvas or wooden board.

3. Cover the painting surface with a layer of acrylic or oil paint.

4. When the undercoat has fully dried, paint over this layer with a contrasting tone. You will have to work fast if you are using acrylic, as the top layer will dry quickly. You can use a retarding medium to alleviate this problem.

5. Scratch into the surface before the top layer of paint dries.

6. Once you have experimented with different tools and marks, take your investigations further by exploring a variety of color combinations and also by combining your scraping techniques.

Look Up

Julia Dault *Steel Magnolias*
Cy Twombly *Foundry, Rome*
Antoni Tàpies *Gray Relief on Black*
Anselm Kiefer *Departure from Egypt*
Frank Auerbach *Railway Arches, Bethnal Green II*

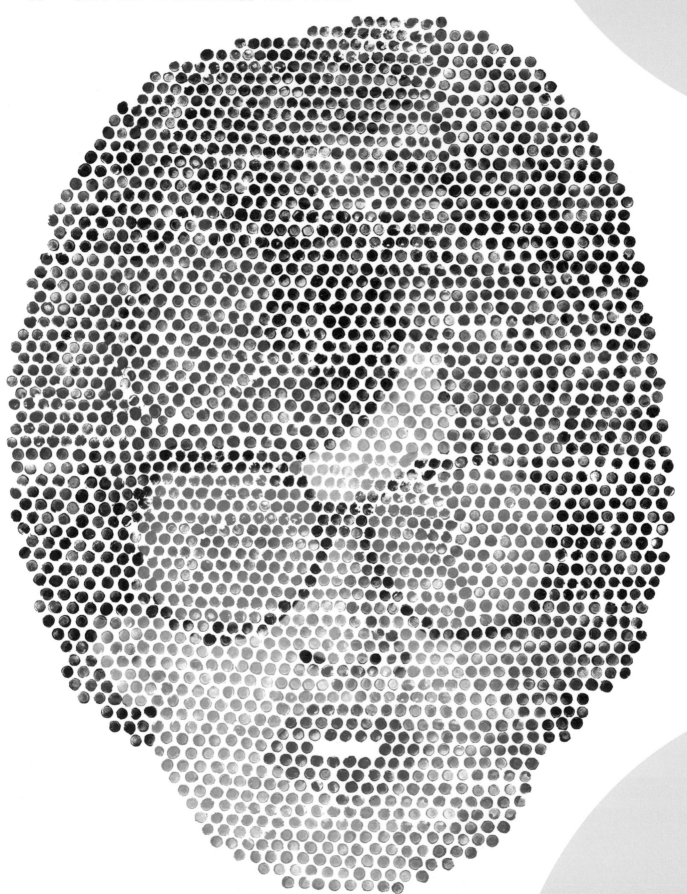

"Everything starts from a dot." Wassily Kandinsky

Polke's Dots

Sigmar Polke (1941–2010) was an artist and photographer who fled communist East Germany in 1953 to take refuge in West Germany. He became fascinated by the new mass media images that he was exposed to in the west. In the 1960s, he produced a series of paintings of images appropriated from newspapers called "Rasterbilder" that imitated the Ben-Day dots process, whereby small dots are placed on a printing plate to create tone. Polke rather ingeniously used the eraser end of a pencil dipped in paint and dabbed onto canvas to mimic the printed dots. Polke joked that "my short-sightedness gave me access to that raster world ... I saw only tiny, lifeless black dots!"

During the same period, the American Pop artist Roy Lichtenstein (1923–97) was also greatly inspired by the Ben-Day dots process. He rolled and stippled paint through the holes of a specially made metal stencil onto canvas, to replicate Ben-Day dots. This became his trademark technique, and he is famous for reappropriating comic-book imagery. However, toward the end of his career, he used the technique to great effect in his still life and landscape paintings.

For this exercise you are going to construct an image solely from a combination of dots. Inspired by Polke, you are going to paint with the eraser end of a pencil.

Method

1. Gather together as many pencils with eraser ends as you can. It's much easier to use a separate pencil for each color, as they are not as easy to clean as paintbrushes. Use acrylic paint on a heavyweight paper that is no smaller than tabloid size.

2. Decide what you want to paint—it should be something simple, nothing too intricate. You can then use one of the pencils to sketch a faint outline of the image onto the paper.

3. Now dip the eraser end of a pencil into the paint and dab the sheet of paper, marking out the key points. Build the painting with different tones, by using a mix of colored dots. Try, if you can, to stick to a uniform pattern of dots.

Look Up

Roy Lichtenstein
 Magnifying Glass
Sigmar Polke *Girlfriends*
Bridget Riley *Black to White Disks*
Yayoi Kusama *Dots Obsession*
Georges Seurat *A Sunday Afternoon on the Island of La Grande Jatte*

You are going to follow on from an earlier exercise on page 20: Your water paintings are going to become the raw material for a collage. You will cut the sheets of textures and patterns and assemble them into a completely new image. This will help you to understand composition and should inspire fresh, inventive work.

Method

1. Collect a selection of water paintings from the "Float on" exercise (see pages 20–21). You can add to these by painting some new textures using sponges, stippling, bubble-wrap prints, and dry brushstrokes on sheets of thin paper. Use wallpaper paste or PVA glue to paste your cutouts onto art board.

2. First plan your collage by drawing rough ideas onto a sheet of paper or into your sketchbook. When you have settled on an idea, you can then draw it out onto the art board. Your composition should be made up of individual graphic shapes and forms that work when pieced together.

3. Think about the composition of your shapes. Do the colors react well? Do the shapes have a compositional balance? Place them onto the surface of your board and take time to arrange and rearrange them into different layouts. You can construct an image that is completely abstract, or you can create a more figurative representation if you prefer.

4. When you are completely satisfied with the composition, begin to paste the separate shapes onto your surface.

Painting with Scissors

In his later years, Henri Matisse (1869–1954) became unwell and was confined to a wheelchair. As a way of adapting his working methods, he adopted a new technique, which he called "painting with scissors." He painted large sheets of paper with a variety of colors using gouache. He then cut up the paper into an assortment of shapes which he assembled into large collages. His alternative technique gave him, as he put it, "a second life." The "Cut-outs" opened up a completely new way of communicating his creative ideas and have been a source of inspiration for many artists.

Eric Carle (b. 1929) is the author and illustrator of the classic children's book *The Very Hungry Caterpillar*. He uses a collage technique that involves hand-painting tissue paper, which is then cut into shapes to make his characters. His imaginative illustrations use minimal composition techniques and bold colors. Carle is inspired by the Expressionist artists, and particularly admires Franz Marc (1880–1916), who focused on representing emotions rather than showing the world in a formal and realistic way.

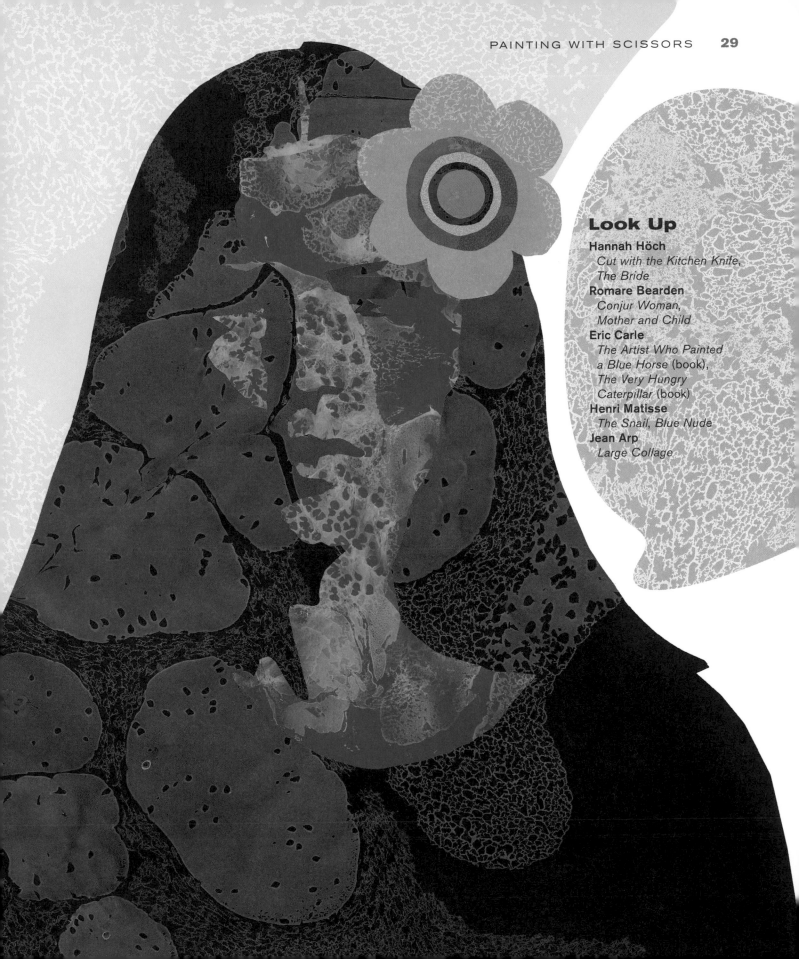

Look Up
Hannah Höch
Cut with the Kitchen Knife,
The Bride
Romare Bearden
Conjur Woman,
Mother and Child
Eric Carle
The Artist Who Painted
a Blue Horse (book),
The Very Hungry
Caterpillar (book)
Henri Matisse
The Snail, Blue Nude
Jean Arp
Large Collage

Form, Light and Shade, and Tone

"Writing has laws of perspective, of light and shade, just as painting does, or music. If you are born knowing them, fine. If not, learn them. Then rearrange the rules to suit yourself."

Truman Capote

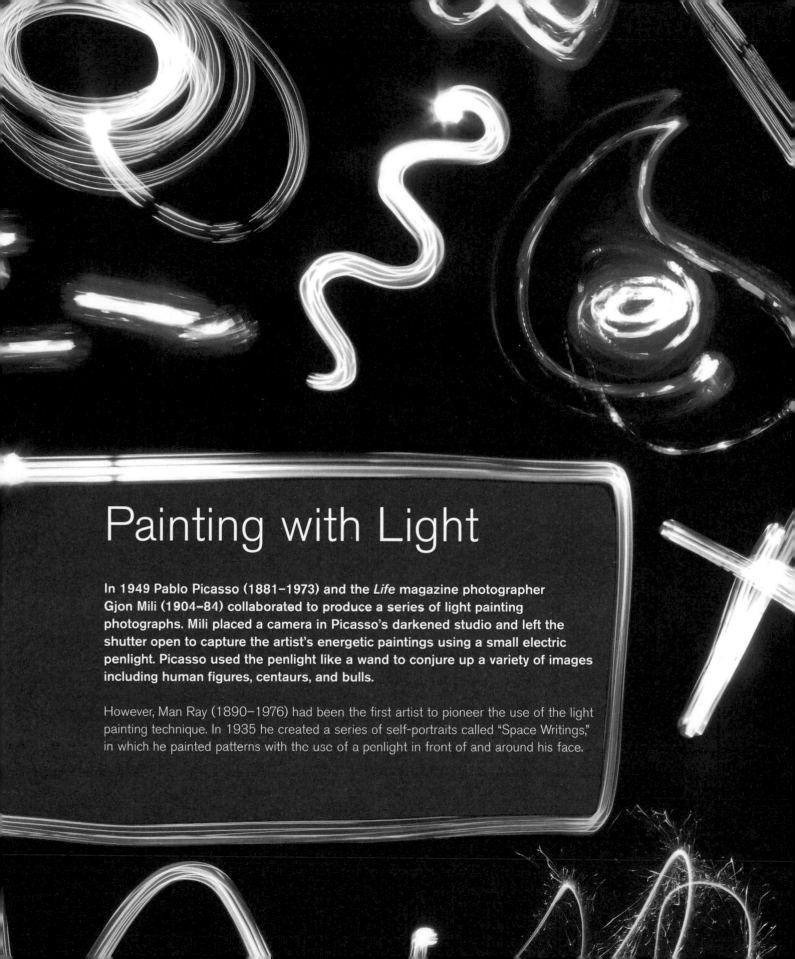

Painting with Light

In 1949 Pablo Picasso (1881–1973) and the *Life* magazine photographer Gjon Mili (1904–84) collaborated to produce a series of light painting photographs. Mili placed a camera in Picasso's darkened studio and left the shutter open to capture the artist's energetic paintings using a small electric penlight. Picasso used the penlight like a wand to conjure up a variety of images including human figures, centaurs, and bulls.

However, Man Ray (1890–1976) had been the first artist to pioneer the use of the light painting technique. In 1935 he created a series of self-portraits called "Space Writings," in which he painted patterns with the use of a penlight in front of and around his face.

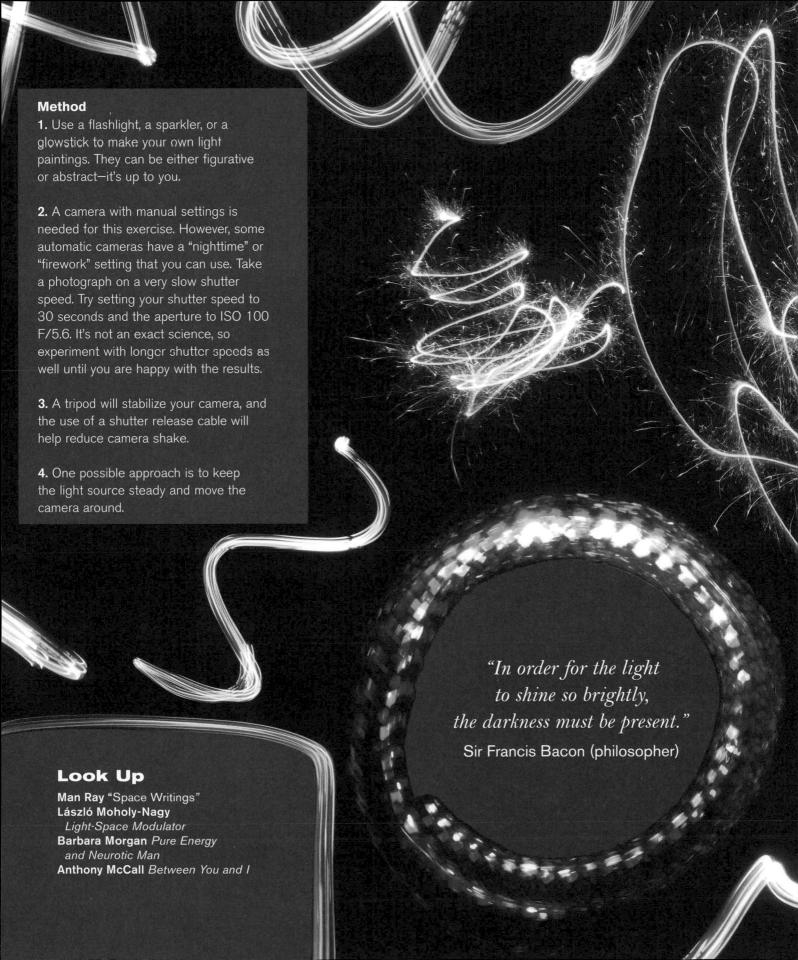

Method

1. Use a flashlight, a sparkler, or a glowstick to make your own light paintings. They can be either figurative or abstract—it's up to you.

2. A camera with manual settings is needed for this exercise. However, some automatic cameras have a "nighttime" or "firework" setting that you can use. Take a photograph on a very slow shutter speed. Try setting your shutter speed to 30 seconds and the aperture to ISO 100 F/5.6. It's not an exact science, so experiment with longer shutter speeds as well until you are happy with the results.

3. A tripod will stabilize your camera, and the use of a shutter release cable will help reduce camera shake.

4. One possible approach is to keep the light source steady and move the camera around.

Look Up

Man Ray "Space Writings"
László Moholy-Nagy
 Light-Space Modulator
Barbara Morgan *Pure Energy
 and Neurotic Man*
Anthony McCall *Between You and I*

*"In order for the light
to shine so brightly,
the darkness must be present."*
Sir Francis Bacon (philosopher)

The German Dadaist artist Kurt Schwitters (1887–1948) fled to the Lake District in England after persecution by the Nazis, for making what they termed "degenerate" art. He coined the term "Merz" (an abbreviation of the German word for commerce, *Kommerz*, for his innovative collaged mixed media pieces that used discarded and natural objects. He incorporated all manner of things, from candy wrappers to newsprint, bus tickets, skittles, rusted metal, and even baby stroller wheels.

Stone Love

The landscape of the Lake District greatly inspired Schwitters to infuse his work with more natural objects such as stones. He used paint to "soften" the hard surface of stones. He is an incredibly influential figure in the world of art, particularly on the work of Richard Hamilton, Robert Rauschenberg, and Eduardo Paolozzi, among others.

Stones are magical objects that are rich in symbolism. As an act of remembrance, small stones are traditionally laid on the graves of loved ones in Jewish cemeteries. Stones are also used in a barbaric form of capital punishment, and are part of the fabric of the buildings that we live in. Amazingly, ancient aboriginal stone arrangements in Australia were used for ceremonies and rituals.

Method

1. For this task you are going to paint onto a stone. One of the best places to find stones and pebbles is anywhere near water. The sea or a river will toss and turn the stones, gradually smoothing them down naturally to make a perfect canvas for paint. Collect a few stones from a pebble beach or riverbank, and place them in a strong bag.

2. Once home, wash the stones to get rid of any dirt or salt that might keep your paint from adhering to the surface.

3. Use acrylic paints and a selection of different-sized brushes. The colors that you choose can work in harmony with the color of the stone or may be in direct conflict with it. It's up to you, and very much depends on your design.

4. Now hold a stone in your hand and study its shape. Will your design wrap around it or will it sit flat on the surface? The form will dictate your design—for example, an incredibly intricate painting won't work on a stone that has a heavily pockmarked surface.

5. Finally, use an acrylic varnish to ensure that your stone art stands the test of time.

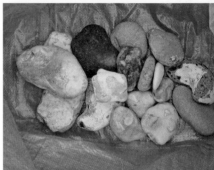

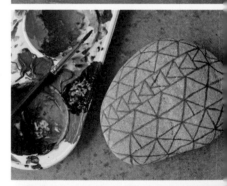

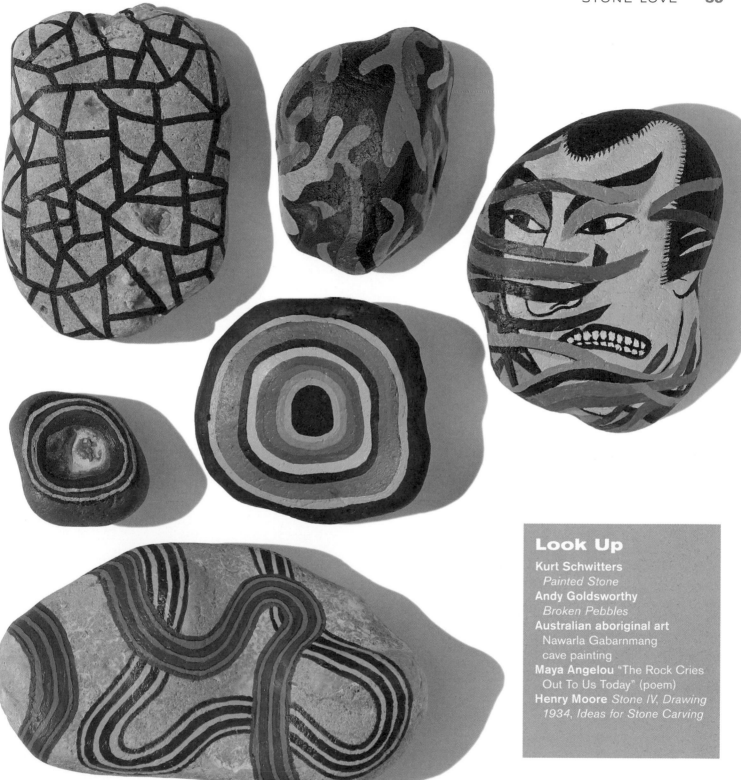

Look Up

Kurt Schwitters
Painted Stone
Andy Goldsworthy
Broken Pebbles
Australian aboriginal art
Nawarla Gabarnmang
cave painting
Maya Angelou "The Rock Cries
Out To Us Today" (poem)
Henry Moore *Stone IV, Drawing
1934, Ideas for Stone Carving*

"A stone is ingrained with geological and historical memories."
Andy Goldsworthy

"Look at how a single candle can both defy and define the darkness."
Anne Frank

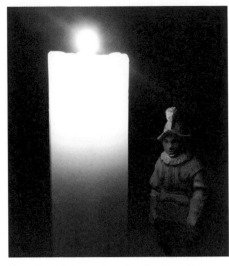

Here, the artist experiments with alternative lighting positions. They highlight one side of the setup with the candlelight.

Next they have outlined the composition with a gray tone in acrylic paint (a mixture of Titanium White and Ivory Black).

By Candlelight

Chiaroscuro is an Italian word that means light and dark. It is an artistic technique that uses the sharp contrast of light and dark to build up a sense of volume and drama.

Chiaroscuro was a technique widely used during the sixteenth century, in Mannerism and in Baroque art. Subjects were lit dramatically by a single light source, usually a candle. In the late sixteenth and early seventeenth centuries, the Italian artist Michelangelo Merisi da Caravaggio developed this technique, creating dramatic lighting contrasts.

You are going to set up some very simple objects and light them with a single light source.

Method
1. Choose a darkened room and cover up all the windows and doors.

2. Use an average-size candle to light your objects. If you feel that it is necessary, you can place two candles together to throw more light on your subjects.

3. You can move your light source around so that you can find the best position to light your subjects.

4. Try out a variety of alternative lighting positions.

5. Illuminate one side of your setup. This light will throw the opposite side of your subject into dark shadow. Try to create a strong contrast between light and dark. This will help model the form of your subject and give the illusion of three dimensions. You can build a sensory drama.

6. Begin to compose your image on the canvas board or work over the top of the sketch with gray paint. You can use acrylic paint or oils if you like.

7. Use a mixture of Titanium White and Ivory Black to begin an underpainting to gradually build up the tones and model the forms.

8. Look closely at the warm colors that illuminate your subjects and begin to apply color over the top of your underpainting. Look closely at the dark shadow areas and darken with the appropriate hues. Ivory Black, Burnt Umber, and Ultramarine Blue can be applied to darken the shadows.

9. Build up your painting by gradually highlighting the areas in full light and darkening the shaded areas. Eventually, you will achieve a painting of high contrast.

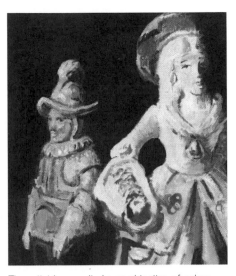

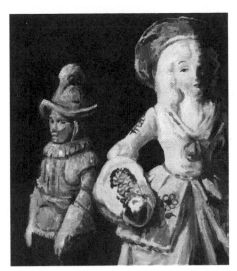

At this stage the artist has built up a tonal underpainting. (This is used as a guideline to establish the differences between light and dark.)

The artist has applied a combination of colors—Cadmium Red, Burnt Sienna, and Burnt Ocher hues—to the underpainting to shade the background character and give him a sense of warmth.

At this stage the foreground character has been modeled with hues of Burnt Umber and Burnt Ocher. The background area has been further darkened with Ivory Black and Burnt Umber.

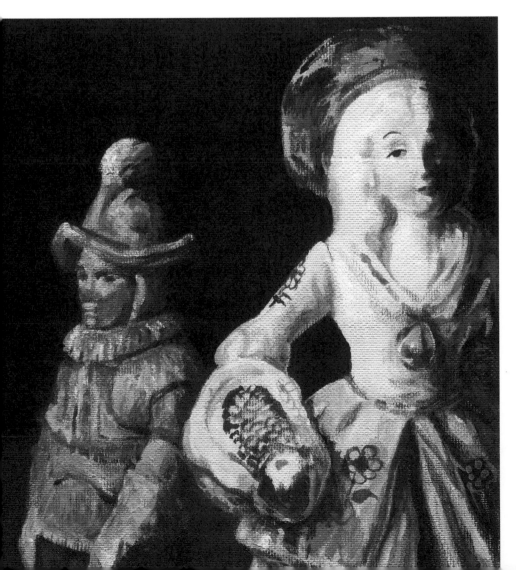

Finally, the contrast of dark and light has been heightened in the painting as a whole. The powerful shadow on the foreground character has been further defined with Ultramarine Blue and details have been applied to the dress. Highlights have been added to further sculpt the forms.

Look Up

Michelangelo Merisi da Caravaggio *David with the Head of Goliath*
Rembrandt van Rijn *Titus as a Monk*
Francisco Goya *The Third of May*
Vincent van Gogh *The Potato Eaters*
Jacques-Louis David *The Death of Marat*
Diego Velázquez *Las Meninas, Old Woman Cooking Eggs*
Johannes Vermeer *Girl Reading a Letter at an Open Window*
Tom Hunter *Woman Reading Possession Order*
Georges de La Tour *Magdalen with the Smoking Flame*

Method

1. Scrunch up a white plastic bag into different shapes, manipulating it so that you can see a range of tones.

2. Paint a canvas, a canvas board, or a piece of wood with a very dark background, using a black or neutral gray acrylic. The dark background will give you the perfect foundation to highlight the white of your subject matter. You are going to paint out the darkness and illuminate your painting.

3. Wait until the background is fully dry and then place the bag before you. Begin to outline the bag's shape on the darkened background.

4. Look at the shapes and tonal forms on the surface of the bag and pick out the mid tones, dark tones, and light tones. You are going to make a patchwork of white tones.

5. When you have filled the shape with a mixture of tones, wait for the paint to dry and begin to look closely at the tonal areas. The darker areas may have different hues, blue-whites, and grays, or there may be warmer whites, for example. Apply different hues where necessary.

"White has the appeal of the nothingness that is before birth, of the world in the ice age."
Wassily Kandinsky

The background has been painted with an undercoat of a dark Carbon Black and Payne's Gray.

Two coats of the dark acrylic have been applied to the entire background.

White Trash

The Dutch painter Piet Mondrian (1872–1944) was one of the leading lights in the De Stijl movement. *De Stijl* is Dutch for "The Style," and was founded by artist Theo van Doesburg (1883–1931) in 1917, as a reaction against the lavish ornamentation of the Art Nouveau movement. The De Stijl artists created a new aesthetic language for all artists to embrace. They believed in simplifying both color and form. Their reductionist approach to art led them to only using primary colors with black and white, and restricting their forms to straight horizontal and vertical lines.

Mondrian felt that white had a spiritual quality, and he exploited its unadulterated purity to the full. The American artist Charmion von Wiegand (1896–1983) highlighted Mondrian's obsession with white when she described a visit to his studio: "Everything was spotless white, like a laboratory. In a light smock, with his clean-shaven face, taciturn, wearing his heavy glasses, Mondrian seemed more a scientist or priest than an artist."

Toward the end of his life, Mondrian's paintings became even more restrained, with large areas of white painted within less complicated grid systems.

Here we are going to paint a sterile white plastic bag. It may seem banal and a little simplistic, but if you study this thin plastic material you will not only see reflecting shapes and forms, but also a complex variety of tones and hues.

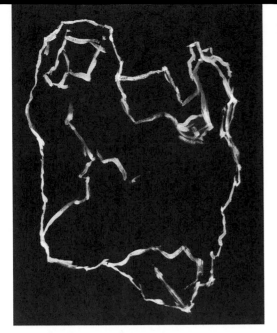

A rough outline of the plastic bag has been sketched out on the background in a medium gray.

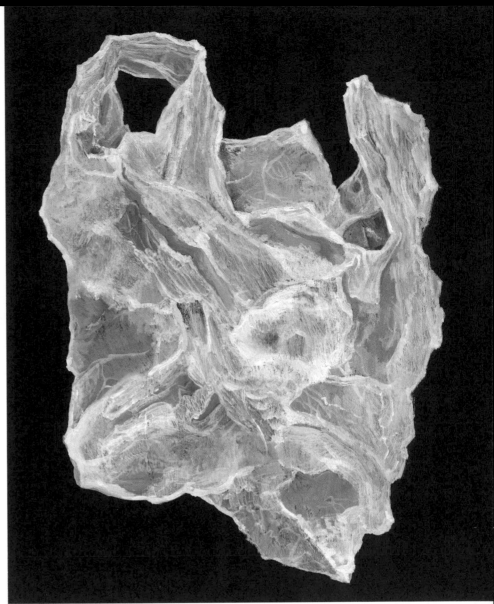

The shape has been completely covered with the inclusion of the lighter tones. Finally, more detail has been applied to the tonal background. The plastic textures, wrinkles, and creases have been accentuated with Titanium White highlights.

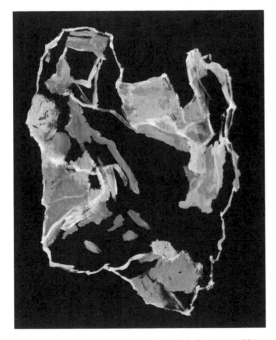

The artist has blocked in the mid and dark tones within the shape.

See Also:

Black is Black, pages 40–41
Gray Matters, pages 42–43
Red Hot, pages 60–61
Blue Monday, pages 62–63
Mellow Yellow, pages 64–65

Look Up

Piet Mondrian *Composition (No. 1) Gray-Red*
Richard Hamilton *The White Album* (The Beatles, album cover)
James Abbott McNeill Whistler *Symphony in White No. 3*
Kazimir Malevich *White on White*
Jasper Johns *White Flag*
Robert Ryman *Series No. 13 (White)*
Gerhard Richter *Weiss (White)*
Le Corbusier *Villa Savoye* (building)

"Black is like the silence of the body after death, the close of life." Wassily Kandinsky

The artist has used a wooden board with a smooth surface. The board has been primed with a layer of neutral gray acrylic (a combination of Middle Gray and Payne's Gray.) The outline of the toast has been simply sketched onto the board with a light gray acrylic.

Here the artist has used Burnt Sienna, Burnt Umber, and Yellow Iron Oxide to outline the crust. The charred bread is formed with the application of Bone Black.

The toast is built up with a combination of blacks. There is a mixture of Bone Black (the textures on the left-hand side), Burnt Umber, and Black (on the right-hand side), and Ivory Black has been added around the edges of the toast.

Black is Black

In 1964 the Abstract Expressionist painter Mark Rothko (1903–70) was commissioned by art collectors Dominique and John de Menil to produce a series of paintings for a chapel in Houston, Texas. The patrons gave him free range to create what he wanted. The Rothko Chapel is a tranquil and meditative space for people of all beliefs.

See Also:
White Trash, pages 38–39
Gray Matters, pages 42–43
Red Hot, pages 60–61
Blue Monday, pages 62–63
Mellow Yellow, pages 64–65

Rothko painted fourteen imposing rectangular canvases with intense black and somber tones. The uncompromising paintings surround the viewer to create a dark, contemplative space. These funereal canvases were a reflection of his state of mind and only a few years later, his deep depression led him to take his own life.

Carbon Black pigments historically have been derived from the carbonization of various organic materials such as wood and bone. Lamp Black was traditionally produced by collecting soot from oil lamps. Bone Black and Ivory Black (very intense blacks) are derived from carbonized bones; Rembrandt van Rijn often painted his models' clothing with Bone Black. Vine Black is a bluish black, created from burning grape stems and vines.

For this exercise, you are going to paint a carbonized object. To help you examine the many and varied possible shades of black, you are going to paint a piece of burned toast.

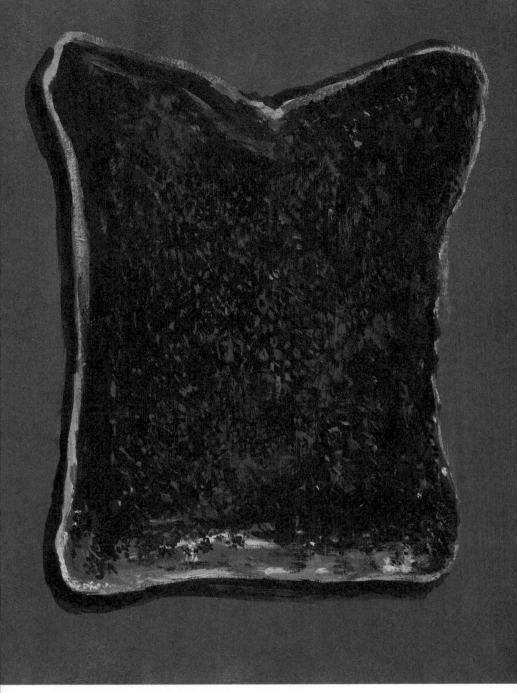

At the final stage, the painting has been given more detail to darken the tone and bring out the charred gray textures.

Look Up

Mark Rothko Rothko Chapel (building)
Francisco Goya *A Pilgrimage to San Isidro*
Rembrandt van Rijn *Old Man with a Black Hat and Gorget*
Frank Stella *The Marriage of Reason and Squalor*
Ad Reinhardt *Black Painting*
Kazimir Malevich *Black Square*
Morton Feldman *Rothko Chapel* (piece of music)

Method

1. There is little more annoying than burning your toast when you're in a rush in the morning. The next time this happens to you, don't throw it away. Set the burned toast aside, and when things are less frenetic you can use it as subject matter for a painting.

2. Use a canvas board or a piece of wood, and paint a neutral gray background with either acrylics or oils.

3. Study the scorched slice of bread, taking a close look at the various textures and tones. You are going to examine the many combinations of tones and pigments that can be mixed to create a range of blacks.

4. Paint the details, like the tiny pockmarks on the surface of the bread.

5. Once you've finished the painting, reward yourself with some toast—be careful not to burn it!

In 1937 Pablo Picasso (1881–1973) painted one of his most iconic and powerful paintings, *Guernica*, in black, white, and gray. The painting was a protest against the aerial bombing of the town of Guernica by the German Luftwaffe in support of Franco in the Spanish Civil War.

Gray Matters

Picasso stripped the painting of color to dramatically depict the destruction and suffering that was inflicted upon the Basque town. He also felt that color often interfered with the structure and form of a painting. His monochrome palette mirrored the newsreels and newspapers of the time and brought the atrocity to the world's attention; the painting was exhibited at the Paris World

Exposition in 1937. *Guernica* is an enduring symbol of the brutality of war, and a tapestry version of the painting hangs in the United Nations building in New York. In 2003, its potency was emphasized when the tapestry was famously covered with a curtain during former U.S. Secretary of State Colin Powell's presentation of the case for the invasion of Iraq.

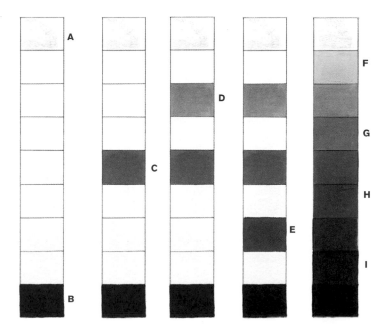

See Also:
White Trash, see pages 38–39
Black is Black, see pages 40–41
Red Hot, see pages 60–61
Blue Monday, see pages 62–63
Mellow Yellow, see pages 64–65

Method
For this exercise we are going to focus on black and white, and all the grays in between.

All colors have tonal value, but achromatic color is any color that is without chromatic content. Black, white, and shades of gray are achromatic colors. Chromatic colors are blue, green, red, and so on.

In 1907, the artist and art theorist Denman Ross (1853–1935) developed a tonal value scale for black and white. The scale (see right) is still used today as an aid to help us identify light, mid, and dark tones.

Denman Ross nine-step value scale
1. Use heavyweight paper with acrylic paint. Divide a rectangle into nine equal sections. Now paint the top section with white **(A)** and the bottom (ninth) section with black **(I)**.

2. Now mix together a medium gray with equal amounts of white and black. Paint this in the section that is halfway between the white and black, **(E)**— mid value.

3. Then mix an equal amount of white and the mid-value gray. Paint this in the section that sits exactly between the white and the mid-gray value, **(C)**—light.

4. Next mix equal amounts of the mid-value gray and

black. Place this between the mid-value gray and black, **(G)**—dark.

5. Finally mix together your four intermediate grays at a value midway between each of the values. i) White with light to produce high light. ii) Light with mid-value to produce low light. iii) Mid-value with dark to produce high dark. iv) Dark with black to produce low dark.

6. Now you have your tonal guide to hand, use it to assess the tonal value of a black-and-white image.

7. Find a colored photograph and convert the picture to grayscale on your computer. Print the image onto a sheet of letter paper.

8. Paint the black-and-white image with either oil or acrylic paint.

9. The dynamics of the image will completely change when the picture is converted into black and white. The image is broken down into light and shade, without the distraction of color. Your eye will be drawn to an area of light against dark. Painting with gray values will also help you study the subtle modulations of tone.

10. Finally, use your value scale to assess the tonal values of your painting.

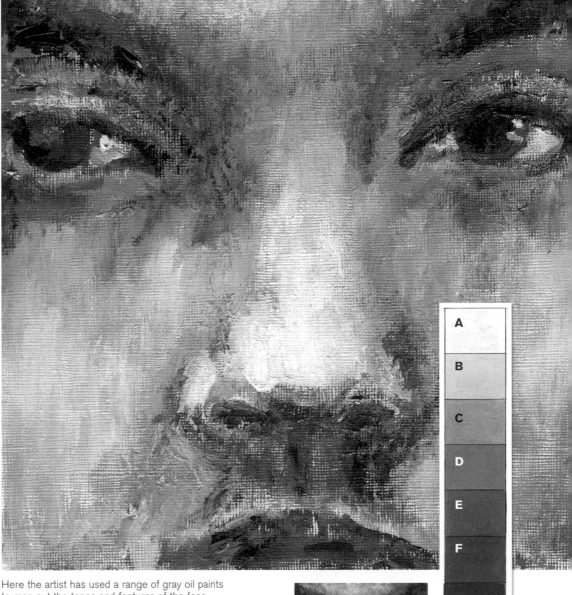

Here the artist has used a range of gray oil paints to map out the tones and features of the face.

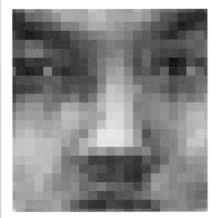

The image shows a pixelated version of the original image. The value scale helps us to assess the tonal values of the painting.

Look Up

Pablo Picasso *Guernica*
Agus Suwage *Marilyn Monroe* from "I Want To Live Another 1000 Years" series
Chuck Close *Big Self Portrait*
Luc Tuymans *Tshome*
Agnes Martin The gray paintings
Jasper Johns *Gray Painting With Ball*

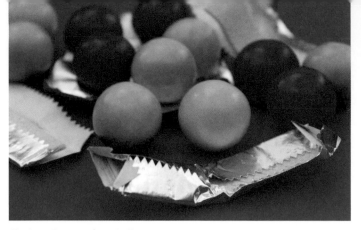

Find a selection of gumballs.

The simple outline of a piece of gum is painted on a neutral gray background.

Gumball

Ben Wilson (b. 1963) is an artist who creates tiny works of art by painting directly onto discarded gum on the sidewalk. He paints the flattened gum with acrylic enamel paints. His mini masterpieces can take up to three hours to complete, and most of his work can be found on the streets of Muswell Hill in London. Frustrated by our consumer-based, throwaway society, Wilson finds it liberating "to make something special out of something that is thrown away."

Look Up

Ben Wilson Chewing gum paintings,
London (see above)
Simone Decker Giant bubblegum
sculptures, Venice
Adi Meirtchak and Adva Noach
Gum Pile Chair

Method

1. Chew on some gum until the flavor disappears. Then place it onto a flat plain surface. You are going to paint a picture of the gum, so you can pinch it into a shape that suits.

2. Now shine a directional light on the gum and observe its textures, structure, and form. If need be, use a magnifying glass to study these details. The highlights, shadows, and gradations of tone will help you to describe the form. Tone helps to create a sense of volume. Grade the tones from light to dark, creating solidity with light and shade.

A directional light shines on the chewed gum to highlight and define the structure and form.

Shadows enliven and give depth to a painting, creating a sense of volume and mass. There are two types of shadows—form and cast. The form shadow sits on the subject, directly opposite to where the light source is hitting it. The cast shadow is made when the subject blocks out the light source beyond it. This shadow is generally much darker and falls onto a nearby surface.

The structure of the image is created with "cast and form" shadows.

The solid form is constructed using tones ranging from light to dark.

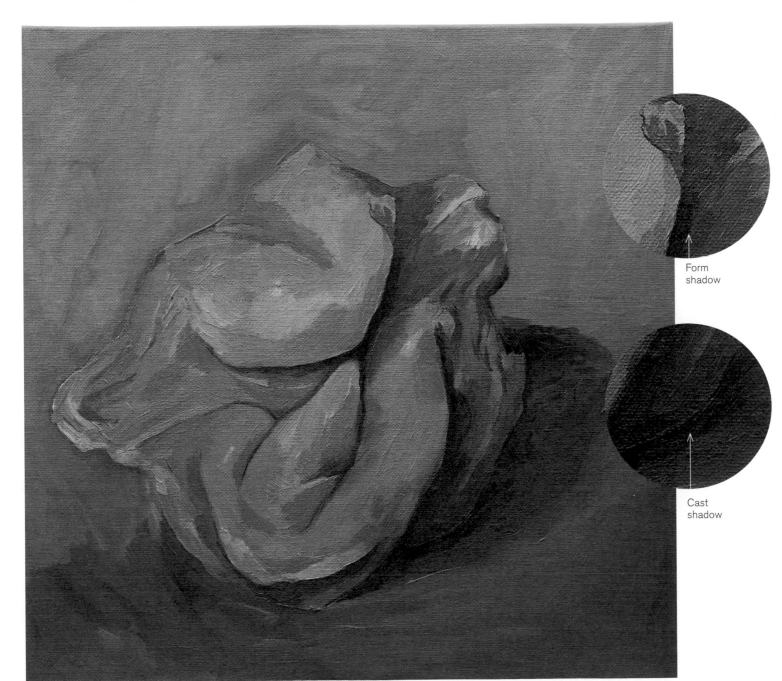

Form shadow

Cast shadow

Contrails are those white lines that you sometimes see in the sky—they are water vapor trails emitted from the exhausts of airplanes. The word "contrail" is a contraction of "condensation trails."

Contrails

In recent years the increase in commercial air travel has led to the proliferation of these artificial clouds crisscrossing the sky.

The landscape and war artist Paul Nash (1889–1946) used contrails to great effect in his dramatic painting entitled *Battle of Britain*. The painting is a symbolic depiction of the aerial battle over the English Channel during the Second World War, where allied forces locked horns with the Luftwaffe. There are swirling white contrails from allied force planes, which rise up victoriously into the sky. This contrasts with the black smoke emanating from the Luftwaffe planes plummeting into the sea.

Your task will be to look up to the sky to observe contrails, and paint them.

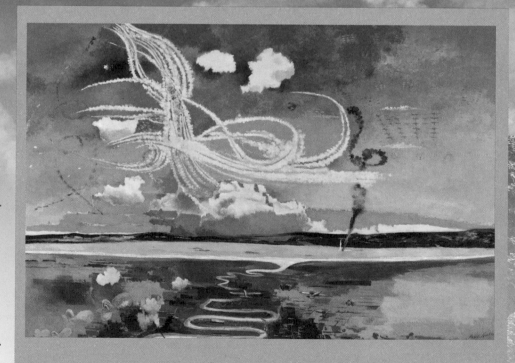

Look Up

Bill Radawec *Out of the Blue, the Turn Around*
Paul Nash *Battle of Britain* (see above)
John Constable *Seascape Study with Rain Cloud*
Franz Kline *Painting Number 2*

Method

1. You will be using household bleach to paint with. You will need to protect your eyes and be careful of splashing bleach onto your clothing. As a precaution you should wear protective gloves.

2. Decant a small amount of bleach into a bottle with a safety cap—and so there is no confusion, write "bleach" on the bottle with a water-resistant marker. Do not use your most precious brushes for this exercise. Old brushes will do, and you might also want to experiment with wooden toothpicks, skewers, or popsicle sticks.

3. Now paint a few sheets of watercolor paper with a wash of undiluted fountain-pen ink. A dark wash will make the bleach contrails stand out. However, you might want to paint clouds by varying the amount of ink that you use. Leave these sheets to dry.

4. Gather your materials and take them to a location that is under a flight path—preferably an open space with a clear view of the sky. Now look up and paint what you see using the bleach. The contrails will often make beautiful abstract compositions in the sky. Experiment with different brushes and tools. You may want to dilute the bleach for a more subtle line.

Bleach is incredibly toxic, so extreme caution is needed when using it for this exercise.

Paint a few sheets of watercolor paper with a wash of undiluted fountain-pen ink.

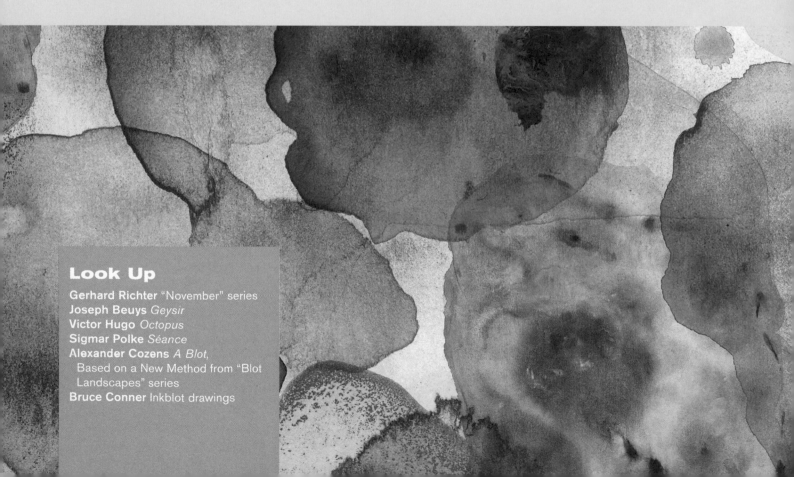

Blot It Out

When we feel uninspired, it is all too easy to sit and stare at a blank canvas hoping that a miracle will happen. Occasionally it does, but most of the time, sadly, it doesn't.

Leonardo da Vinci (1452–1519) would sometimes be absorbed by the dirt and stains that marked his wall—he saw "mountains, ruins, rocks, woods, great plains, hills, and valleys in great variety." These simple observations would feed his imagination.

Gerhard Richter's (b. 1932) "November" series is a sequence of serendipitous inkblot paintings. He was inspired by the accidental spillage of some marker-pen ink onto some absorbent paper. The black ink seeped through the paper, and he was fascinated by the marks that appeared on the other side. Richter then experimented with a variety of thinners, and began to manipulate the blots to create beautiful patterns. He printed duplicates of the parallel images so that both sides could be viewed simultaneously.

You too are going to create blots. This exercise will help you to discover the creative potential of paint and give you a kick start to develop your own creative ideas.

Look Up

Gerhard Richter "November" series
Joseph Beuys *Geysir*
Victor Hugo *Octopus*
Sigmar Polke *Séance*
Alexander Cozens *A Blot*, Based on a New Method from "Blot Landscapes" series
Bruce Conner Inkblot drawings

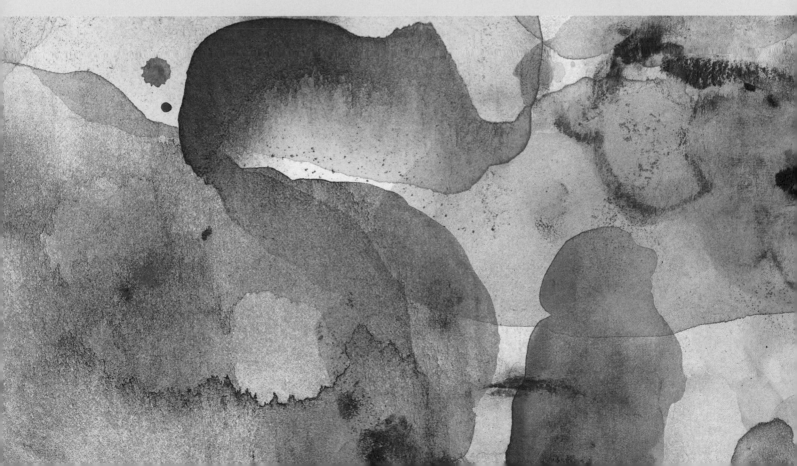

Method

1. Find some absorbent paper—it could be thin watercolor paper, blotting paper, or even an unfolded paper napkin. Use watercolor paint.

2. Paint clean water puddles on the paper, and then drip light-colored paint onto them. Leave the drips to evolve on the page. You can manipulate the blots with a brush or by gently blowing on them.

3. Leave the blots to dry and then create a new layer with darker tones. Repeat this process until you are happy with the results, or until the paper can't take it anymore.

4. Don't forget to study the underside of the paper as well, to see if the blots have penetrated it.

"… if you look upon an old wall covered with dirt, or the odd appearance of some streaked stones, you may discover several things like landscapes, battles, clouds, uncommon attitudes, humorous faces, draperies, etc. Out of this confused mass of objects, the mind will be furnished with an abundance of designs and subjects perfectly new."

Leonardo da Vinci, *Treatise on Painting*

An Exploration of Color

*"I try to apply colors like words that shape poems,
like notes that shape music."*

Joan Miro

Colorful Language

Our perception of color is made up of a complex mix of psychological and physiological responses, alongside cultural and natural associations.

It is common knowledge that a red faucet will produce hot water and a blue one will produce cold. This universal language is based on the warm and cold tones of the color spectrum. Things get more interesting when cultural anomalies come in to play—for example, the sharp contrast between the white wedding dresses often worn by brides in the West and the white worn to funerals in some countries in the East.

Most artists' paint manufacturers don't veer too far from the staple range of colors. However, a decorators' paint manufacturer might have hundreds of variations of one color. This is partly due to the rise of the lucrative DIY paint

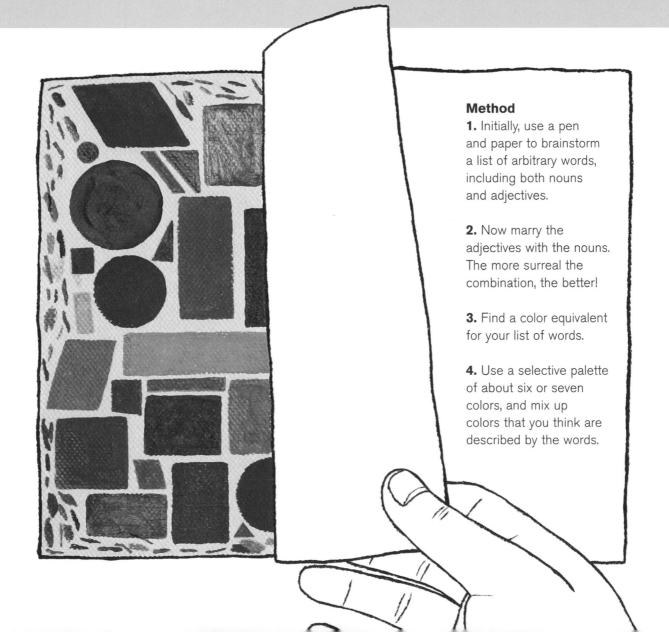

Method

1. Initially, use a pen and paper to brainstorm a list of arbitrary words, including both nouns and adjectives.

2. Now marry the adjectives with the nouns. The more surreal the combination, the better!

3. Find a color equivalent for your list of words.

4. Use a selective palette of about six or seven colors, and mix up colors that you think are described by the words.

"Color is the language of the poets." Keith Crown

market, where people use paint straight from the can, without mixing. This market is perhaps where the use of language relating to color is most creative, as compared to the Pantone® colors that designers and printers reference, which are mostly made up of number and letter codes. Who would be able to guess what color "Pantone 7487 C" was without the chart to refer to, for example? However, we can all imagine what "Melon Sorbet" looks like.

This exercise will get you to really think about color beyond the palette. How do you see colors, and what words would you use to describe their subtleties?

Look Up

Josef Albers "Homage to the Square" series
Reid Miles Album cover design for *True Blue* by Tina Brooks
Damien Hirst *Carbon Dioxide*

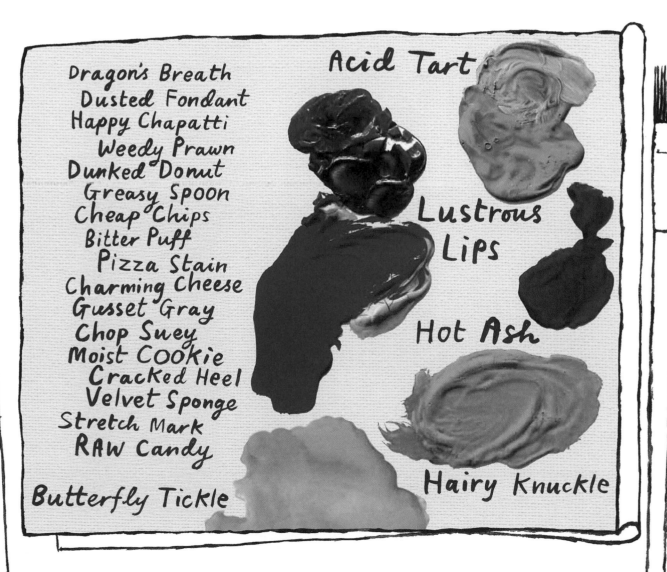

Dragon's Breath
Dusted Fondant
Happy Chapatti
Weedy Prawn
Dunked Donut
Greasy Spoon
Cheap Chips
Bitter Puff
Pizza Stain
Charming Cheese
Gusset Gray
Chop Suey
Moist Cookie
Cracked Heel
Velvet Sponge
Stretch Mark
RAW Candy
Butterfly Tickle

Acid Tart
Lustrous Lips
Hot Ash
Hairy Knuckle

Kandinsky's Colors

The Russian artist Wassily Kandinsky (1866–1944) wrote in his influential book, *On the Spiritual in Art,* that "painting has two weapons at her disposal—color and form." He was deeply fascinated by the psychology of color and its relationship with form. He believed passionately in the power of color and its ability to evoke emotions and feelings in the viewer. He encouraged artists not only to train their eyes to see color, but also their souls.

While teaching at the Bauhaus in the 1920s, Kandinsky devised a simple questionnaire for his students that required them to assign the three primary colors—yellow, red, and blue—to each of the three simple geometric shapes below.

Inspired by his questionnaire, your task is to paint these shapes with the primary colors that you feel best describe and correspond with the shapes. Kandinsky had his own theory about what colors work best (see page 157). However, he was open to other "discordant" responses and conceded that they could "show the way to fresh possibilities of harmony." The test is very subjective, so hold off looking at his results and compare them with yours after you've completed the exercise.

Method
1. You can use any medium, but paint onto a white surface.

2. Use the three primary colors straight from the tube.

3. Look at the shapes and respond instinctively. The shapes don't have to be accurately rendered, but should resemble the shapes below.

4. You may want to write down your explanations for your choice of color and shapes.

5. Now have a look at Kandinsky's results (see page 157).

Kandinsky's Questionnaire:
Fill in these forms with the colors yellow, red, and blue.

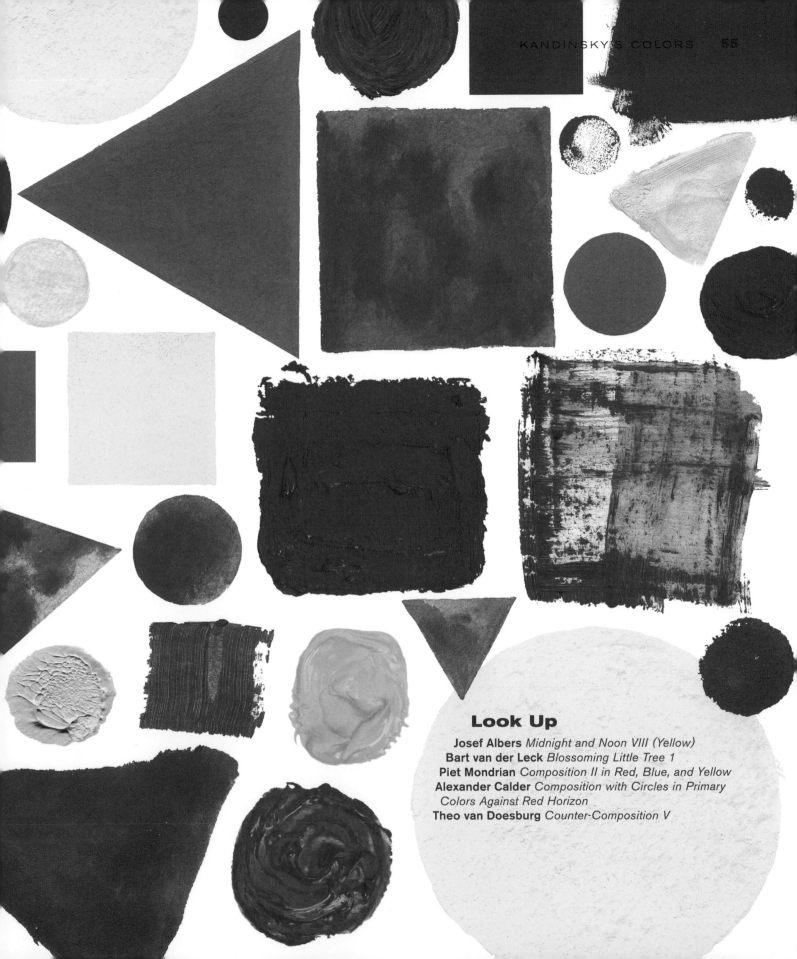

Look Up

Josef Albers *Midnight and Noon VIII (Yellow)*
Bart van der Leck *Blossoming Little Tree 1*
Piet Mondrian *Composition II in Red, Blue, and Yellow*
Alexander Calder *Composition with Circles in Primary Colors Against Red Horizon*
Theo van Doesburg *Counter-Composition V*

"Color is life, for a world without color seems dead."

Johannes Itten

Sir Isaac Newton (1642–1727) is universally accepted as the inventor of the first color wheel in 1666. He initially passed light through a prism to separate the spectrum into seven colors—red, orange, yellow, green, blue, indigo, and violet. Newton then divided each segment of a circle according to the proportion of color wavelength. This meant that the dimensions of the segments were irregular.

Reinvent the Wheel

Johann Wolfgang von Goethe (1749–1832) then modified Newton's original theory by analyzing the psychological effects of colors. He was the first theorist to define color in terms of warm or cool. His book, *Theory of Colors*, included a wheel that then evolved into a triangle.

Later, the Swiss artist Johannes Itten (1888–1967) developed the work of Newton, Goethe, and others to shape his own color theory. Itten's ideas became part of the curriculum at the Bauhaus and he is now seen as the most important color theorist of the twentieth century.

Itten's textbook, *The Art of Color*, defined his theories and included a color wheel with a combination of 12 hues. Yellow was at the top of the wheel, because he felt that we see yellow as the lightest primary color. He wasn't dogmatic about his theories and felt that if artists made masterpieces intuitively without knowledge of the laws of color, then "un-knowledge is your way." To this day, artists, designers and academics still refer to his theories on color.

Primary

Tertiary

Secondary

Tertiary

Cool colors recede

Primary

Tertiary

Secondary

Look Up

Johannes Itten *The Art of Color*
Isaac Newton Color wheel, 1666
Moses Harris Color wheel, 1766
Johann Wolfgang von Goethe *Theory of Colors*
Philipp Otto Runge Color sphere, 1810
Alejandro Puente *Everything goes. Primary and Secondary Colors Brought up to White*

Primary Colors
All colors are a combination of these three hues.

Secondary Colors
Created by mixing the three primary colors.

Yellow *Red* *Blue*

Green *Orange* *Purple*

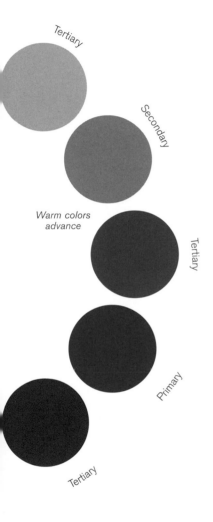

Tertiary

Secondary

Warm colors advance

Tertiary

Tertiary

Primary

Tertiary

Tertiary Colors

Created by mixing a primary and a secondary color.

Yellow-orange *Red-orange* *Red-purple*

Blue-purple *Blue-green* *Yellow-green*

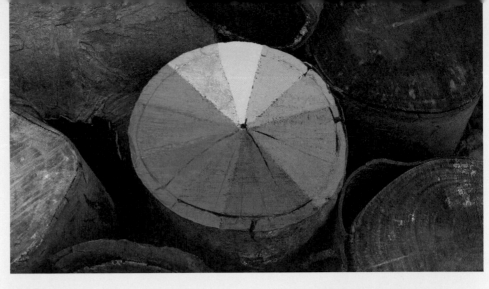

Method

1. You are going to paint a Johannes Itten color wheel, but with a twist. Color is all around us and is at its most intense in nature. Take your three primary color tubes of acrylic paint, brushes, and a mixing palette outdoors and paint your wheel on a rock, the top of a tree stump, or even a large dried leaf.

2. Now divide the circle into twelve equal segments.

3. Paint the three primary colors within your divided circle in opposing positions to each other. Start with yellow at the top, and then move three segments around clockwise and paint the blue segment. Then move around again clockwise, three segments from the blue, to paint the red.

4. To make the secondary colors, mix equal amounts of yellow with red to make orange and paint the segment directly between the two primaries. Now mix an equal amount of yellow with blue to make green and paint the segment between these two primary colors. Finally, mix the red with the blue to make a purple, and once again paint this in the segment between the two primaries.

5. To make the tertiary colors, mix equal amounts of the colors that sit next to each other, and paint them into the empty segments.

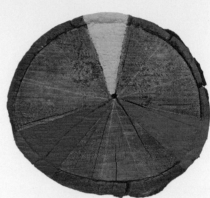

The Bezold Effect is an optical illusion, named after a German professor of meteorology, Wilhelm von Bezold (1837–1907). He discovered that a color may appear different depending on its relationship with adjacent colors.

▲ Notice how the tonal values of this painting change completely when the colors are surrounded by the opposing tones. The dark outlines make the fill color appear much brighter in tone; the white outlines make the background appear darker.

Bezold Effect

Here, you will make a painting investigating the Bezold Effect. This exercise will give you an understanding of color assimilation; how colors and tones can react with each other in a variety of ways to create different visual effects.

You will need some fine paintbrushes (synthetic or horsehair), two sheets of stretched paper, and gouache or acrylic paint.

Look Up

Bridget Riley *Cataract 111*
Ian Davenport *Poured Reversal Painting: Light Blue, Blue*

Method

1. Draw a very simple pattern made of a variety of shapes onto a sheet of paper. They can be abstract shapes or representational.

2. Use a piece of tracing paper and, with a soft pencil, trace the outlines of your pattern.

3. Now turn the tracing paper over and trace over the lines once again onto the opposite side. The pattern is now drawn on both sides of the paper.

Stretch sheet of watercolor paper to a board, repeat with a second.

Trace some shapes. Flip over and go over the lines on the reverse of the trace.

Transfer the image and paint the background.

Use a contrasting color to fill the shapes.

Stay inside the shapes with your paint.

Outline the shapes with a dark outline.

4. Place the tracing onto the stretched paper with your image the correct way up facing you, and stick it down with masking tape so that it can't move.

5. Use a pencil to gently rub over the lines once again so that a pattern begins to appear underneath. The image will now be transferred onto the stretched paper. You can touch it up with a pencil if necessary.

6. The reverse drawing can also be reproduced by placing the paper onto a window pane. The paper will become transparent as the light shines through and the lines can be traced.

7. Reuse your tracing and transfer it to the second piece of stretched paper.

8. Repeat the rub-down process so that you have two duplicate patterns.

9. Begin to paint the background color and try to paint carefully around the shapes. Paint as flat a color as possible. Acrylic paint is good for this.

10. Now paint the shapes themselves, filling them in, once again trying to lay down a flat color.

11. Outline the shapes in the first painting with a dark outline.

12. Finally, outline the shapes in the second painting with a white outline.

"If one says 'Red' (the name of a color) and there are 50 people listening, it can be expected that there will be 50 reds in their minds. And one can be sure that all these reds will be very different."

Josef Albers, *Interaction of Color*

A simple outline of the composition is sketched in with Alizarin Crimson.

Red Hot

Red is a primary color and can be mixed with other colors from the spectrum to produce a diverse assortment of hues. Vermilion, for example, is a color that is a mixture of orange and pure red. The color red has been used for thousands of years as a focal point to draw our attention. The El Castillo cave paintings in Spain are believed to be over 40,000 years old, and contain hand stencils that were produced using red ocher pigments. Neolithic hunters believed that red had life-giving properties, and they used red ocher to decorate the burial sites of their deceased. Red ocher pigment was created using naturally tinted clay. The pigment was mixed into a paste using various natural binders, including blood and urine.

Remember to wash your hands after handling chilies; alternatively, you can wear gloves.

You are going to explore a range of reds by painting chili peppers. Place an assortment of peppers in a simple arrangement. As the peppers ripen, they change color from green to yellow to orange to red. They are therefore a perfect subject to study in terms of the breadth of possible reds—rose reds, orange reds, right through to the purple reds that can be found in the shaded areas and shadows.

Method

1. Gather together at least three chili peppers that offer up a variety of hues of red. The peppers used in this painting are a type of extremely hot capsicum pepper, particularly popular in the Caribbean, called Scotch bonnet. It is one of the most intensely hot peppers, and the redder it becomes, the more potent it is. Its name is derived from its visual resemblance to the Scottish tam-o'-shanter cap.

2. Group the peppers together and arrange them on a neutral or light-colored background.

3. Find a canvas, canvas board, or piece of wood, and use gesso to prime the surface. You will use oil paints.

4. Outline the composition with Alizarin Crimson, or a violet.

5. Begin to block in the reds, and study the shadows and the areas that are highlighted. What happens to the red hues in these areas?

6. Look at the shadows that are created. Can you see any reflected color in the shadows?

7. Continue to block in the color until each pepper has a combination of tones and hues.

See Also:
White Trash, pages 38–39
Black is Black, pages 40–41
Blue Monday, pages 62–63
Mellow Yellow, pages 64–65

The background is blocked in, concentrating on the light and shadows.

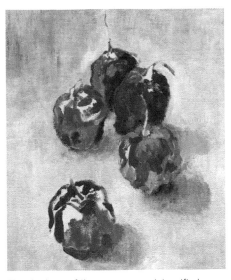

The shadows of the peppers are intensified. A variety of reds are applied to further define the individual forms.

The colors are blocked in, and each pepper is painted with a combination of tones and hues.

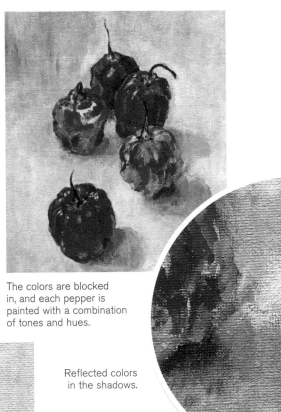

Reflected colors in the shadows.

The final image shows a varied combination of reds. The orange reds highlight the forms, and the purple reds strengthen and define the shaded areas.

Look Up

Roy Lichtenstein
 Red Painting
Anish Kapoor
 To Reflect an Intimate Part of the Red
Albert Lamorisse
 The Red Balloon (film)
Mark Rothko
 Orange Red Orange
Henri Matisse
 The Red Studio
Philip Taaffe
 We Are Not Afraid
Josef Albers *Articulation*
Jean-Baptiste Simeon Chardin *A Basket of Wild Strawberries*
Paul Cézanne *Still Life with Apples*

See Also:
White Trash,
pages 38–39
Red Hot,
pages 60–61
Mellow Yellow,
pages 64–65

Look Up

Picasso *Celestina, The Old Guitarist*
Yves Klein *IKB Blue*
Titian *Bacchus and Ariadne*
Vincent van Gogh *Starry Night*
Mark Rothko *No. 14 White and Greens in Blue*
Franz Marc *The Large Blue Horses*
Henri Matisse *Blue Nude 11*

Mellow Yellow

Yellow is not only associated with the warmth and radiance of the sun. It can be the color of hope, happiness, joy, and optimism. In complete contrast, yellow can also impart negative associations, conjuring up a sense of decay, sickness, and even cowardice.

"How wonderful yellow is. It stands for the sun."
Vincent van Gogh

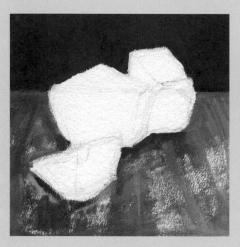

Here, the artist blocks in the background area with darker tones of Burnt Umber and Cobalt Blue.

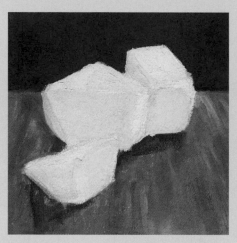

They now block in the foreground area with a flat yellow base color.

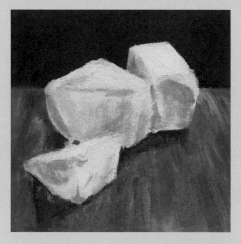

The paint is mixed to a thick buttery texture. The tones and colors are gradually applied, revealing the reflected light on the surface of the butter.

Vincent van Gogh (1853–90) was renowned for his use of yellow and the color predominates in many later paintings. There is much speculation as to why, from noting his predilection for absinthe, which can result in yellow-tinged vision, to suggesting various eye conditions such as glaucoma and cataracts.

In 1888, he moved from Paris to the warmer climate of Arles in the south of France. He immediately set up a studio there, and the building's yellow exterior walls inspired him to paint *The Yellow House*. "What a powerful sight, those yellow houses in the sun," he wrote. His friend and fellow artist Paul Gauguin came to visit, and decided to stay for a while. Van Gogh painted his signature sunflowers to cover the walls of Gauguin's room.

Here we are going to observe and paint a slab of butter. This simple subject will help you to minimize your palette to attain the essential tones necessary to describe light and form.

Method

1. Open the refrigerator and find a slab of butter. Position it in a place where there is a directional light source.

2. Observe it from every angle, and pay particular attention to the tonal values of the slab.

3. Look at the range of yellow hues that will help to create form and structure in your painting.

4. You may want to paint the slab of butter as it stands. However, why not challenge yourself and take a knife to the butter to break up its structure?

See Also:
White Trash, pages 38–39
Black is Black, pages 40–41
Gray Matters, pages 42–43
Red Hot, pages 60–61
Blue Monday, pages 62–63

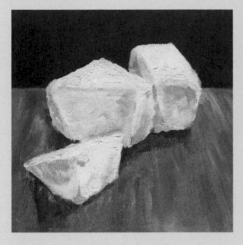

Here, the artist uses a simple palette for the butter tones, including Cadmium Yellow, Yellow Ocher, Burnt Sienna, and Titanium White. The background areas are further built up.

5. Look once again at how the different tones of the butter help to define the forms.

6. Use a simple palette for the butter tones—Cadmium Yellow Light and Medium, Yellow Ocher, and Titanium White. Burnt Sienna, Burnt Umber, and a touch of Cobalt Blue were used for the background.

7. You may choose to use either a palette knife or a brush to paint with oils. Take a sheet of paper from an oil canvas pad, a canvas, or a canvas board to paint on. Begin your painting by lightly sketching out the shapes and forms you see.

8. Block in the background with darker tones that will accentuate the yellow of the butter.

9. Next, block in the foreground area with a flat yellow base color.

10. Now begin to block in the yellows of the butter itself. Mix the paint so it's a thick, buttery texture. Build up the tones gradually and assess whether there are any colors reflected onto the shiny surface. Here there are some areas of blue added to the shaded areas and some yellows are reflected in the foreground.

Look Up

Antoine Vollon *Mound of Butter*
Josef Albers *Homage to the Square: Departing in Yellow*
Mark Rothko *Yellow and Gold*
Vincent van Gogh *Still Life–Vase with Fourteen Sunflowers*
Olafur Eliasson *The Weather Project*
Philip Taaffe *Yellow Painting*
František Kupka *The Yellow Scale*
Joseph Marioni *Yellow Painting*

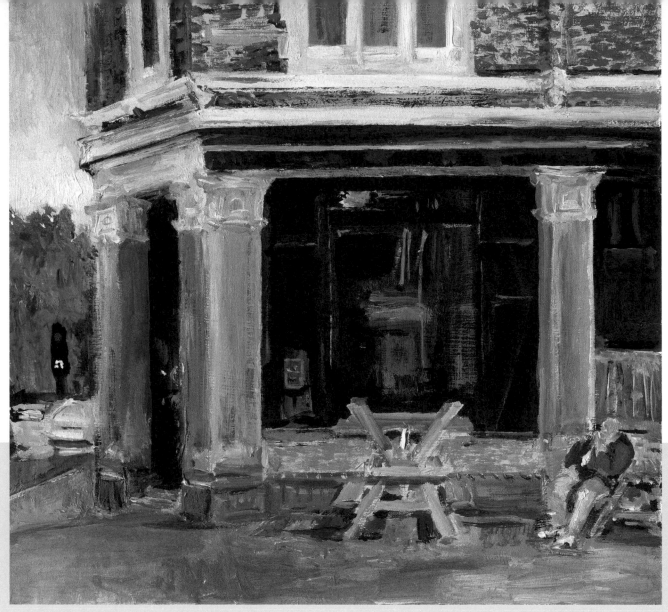

Describe the mood and subtle nuances of the scene by using tonal variations to describe the transient world before you.

As Night Follows Day

Claude Monet's observations of haystacks in Giverny and the façade of Rouen Cathedral were painted at different times of the day. He used thick, impasto paint (see page 14) and combined colors and hues to create a vibrant and expressive mood. He studied how the change in light affected his subjects as the day progressed, and used tonal value to describe these subtle and ephemeral transformations.

This exercise is an opportunity for you to get out onto the street and paint a scene at different times of the day. You are going to create a painting as the sun rises and another at dusk.

You will observe and apply tonal values to your painting to reflect the lighting variations that will occur during the course of the day.

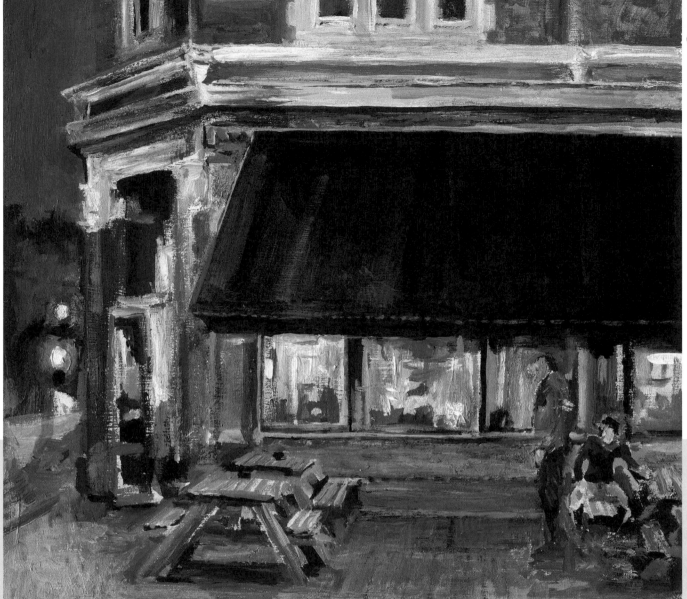

Increase the thickness and density of the
paint to give your picture contrast and vigor.

Method

1. Find a café, bar, or restaurant that
is open from morning until evening.
Sit outside and turn your seat to look
in on the building. Now order a drink,
and get painting!

2. Use acrylics to paint on a small
canvas sketch pad. As time moves on,
analyze the direction and the intensity
of the shadows. Respond to the
changes in atmosphere and light.

3. Return again at dusk to sit in the
same position to document the same
view. Are there any physical changes,
such as people moving or objects
appearing? Notice the differences in
tonal value and capture these changes.

Look Up

Claude Monet "Haystacks" series
Claude Monet "Rouen
Cathedral" series
David Hockney *Woldgate Woods,
21, 23 & 29*
Roy Lichtenstein *Rouen Cathedral
Set V*
Edward Hopper *Nighthawks,
Early Sunday Morning*

Digital Canvas

David Hockney (b. 1937) wears a customized suit, originally made with pockets large enough to fit his sketch pad. The pockets are fortunately just the right size to house an upgraded alternative, the iPad. He prefers this tool to a conventional sketch pad, using it to record and represent the subjects that interest him. As Hockney puts it, "… you don't have the bother of water, paints, and the chore of clearing things away."

Digital tools such as tablets offer up a number of refreshing possibilities—one of which is convenience. They are a practical size and easily transportable. A tablet can be extremely useful as an aide-memoire: You can use it to take quick visual notes for later reference. The drawing and painting apps tend to give a luminosity of color that you can take full advantage of. This is also an extremely democratic medium. Anyone can use a digital tablet to create their own work of art, and seconds later send that image to anyone, anywhere in the world.

The only downside to a tablet is that because it is reflective it can be difficult to use under the glare of direct sunlight; it is sometimes frustrating to use outside. Here, despite its limitations, we are going to exploit and explore this new medium to its full extent.

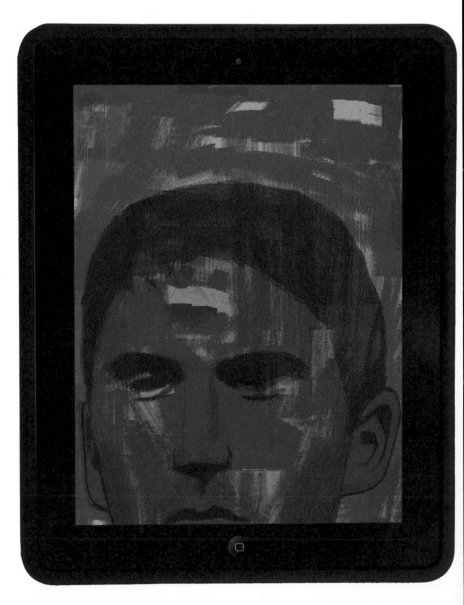

Look Up

David Hockney *The Arrival of Spring in Woldgate, East Yorkshire*
Takashi Murakami *Flowers from the Village of Ponkotan*
Gilbert and George *Bowery*
Francesco Clemente *Perfect*
eBoy *Nelson Mandela*

"It is thought that new technology is taking away the hand (I'm not so sure). If you look around a lot is opening up."

David Hockney (on the iPad)

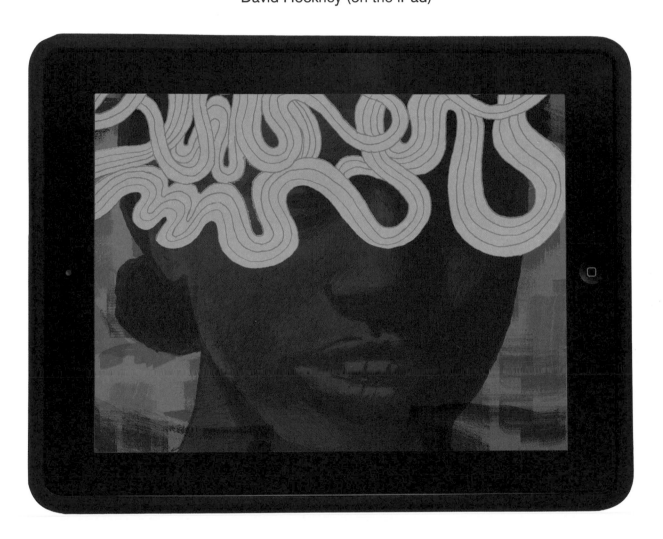

Method

1. Use a tablet and painting app to create your own digital work of art. (There are a variety of painting and drawing apps on the market to choose from.)

2. Think about the composition, textures, and colors as though you were creating a conventional painting. Experiment with different painting tools. David Hockney prefers to use the edge of his thumb to paint with, but you can use a finger, a stylus, or a mouse.

3. When you are satisfied with the result, you can email your painting to friends for an immediate critique.

In 1972, the Cuban-American performance artist, Ana Mendieta (1948–85), made a series of works entitled "Glass on Body." She was interested in using and interpreting her own body as a living sculpture. Mendieta pressed her naked frame against a sheet of clear plastic to reveal her contorted features.

Press the Flesh

In 1995 the artist Jenny Saville (b. 1970) collaborated with the photographer Glen Luchford (b. 1968), to produce a series of self-portraits that set out to challenge the traditional idea of feminine beauty. Like Mendieta's series, the photographs were taken through a large sheet of clear plastic. Saville's face and body were pressed flat onto the plastic, becoming distorted and disfigured. She said: "The way women were depicted didn't feel like [my body], too cute. I wasn't interested in admired or idealized beauty." However, Saville is best known for her powerful, large-scale figure paintings. Her corpulent figures completely fill the canvas and appear like anatomical studies of meaty flesh. She admires painters such as Lucien Freud, Francis Bacon, and Willem de Kooning and prefers to paint with oils, as the medium gives substance and weight to her work.

You are going to make a study of flesh in oils. Oils dry slower than acrylic paints and so it is easier to blend and mix skin tones.

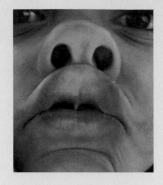

Method

1. Ask a willing model to press their face against a window pane and take a series of photographs.

2. Have a look at the results and choose one image to paint. You are going to paint the twisted and deformed flesh that is revealed through the transparent surface.

3. Begin to outline the image onto the surface in a neutral tone of oil paint.

4. To flesh out an idea means to give it substance, structure, and form. Study the variety of tones, colors, and shades of the compressed skin. The tone and color will be completely different at these points as the blood vessels are compressed. With Caucasian skin for example, the skin will take on a bluish hue. Is the flesh taught or saggy; is it paper-thin, thick, or plump? Consider the curves and subtleties of the pressurized lips. Is the Cupid's bow above the upper lip visible, or completely flattened by the glass?

5. Think about the flesh that immediately surrounds the lips. This area is called the "vermilion border," and the skin here normally appears more ruddy; however, darker skin has more melanin in this area and therefore the color will appear more opaque. The skin of our lips is extremely thin, and in Caucasian skin the blood vessels are more visible.

Here, the image is outlined on the surface of the canvas with a neutral tone.

Where the pressure points are more prominent, the skin in this image is painted with bluish hues.

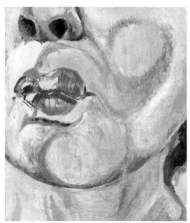

Cadmium Red and Pyrrole Red are applied to the skin. Yellow ochers are introduced for a Caucasian complexion.

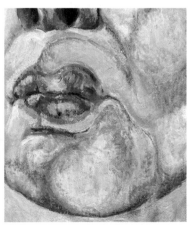

Here the artist focuses on the flesh tones surrounding the lips; the blood vessels are clearly visible.

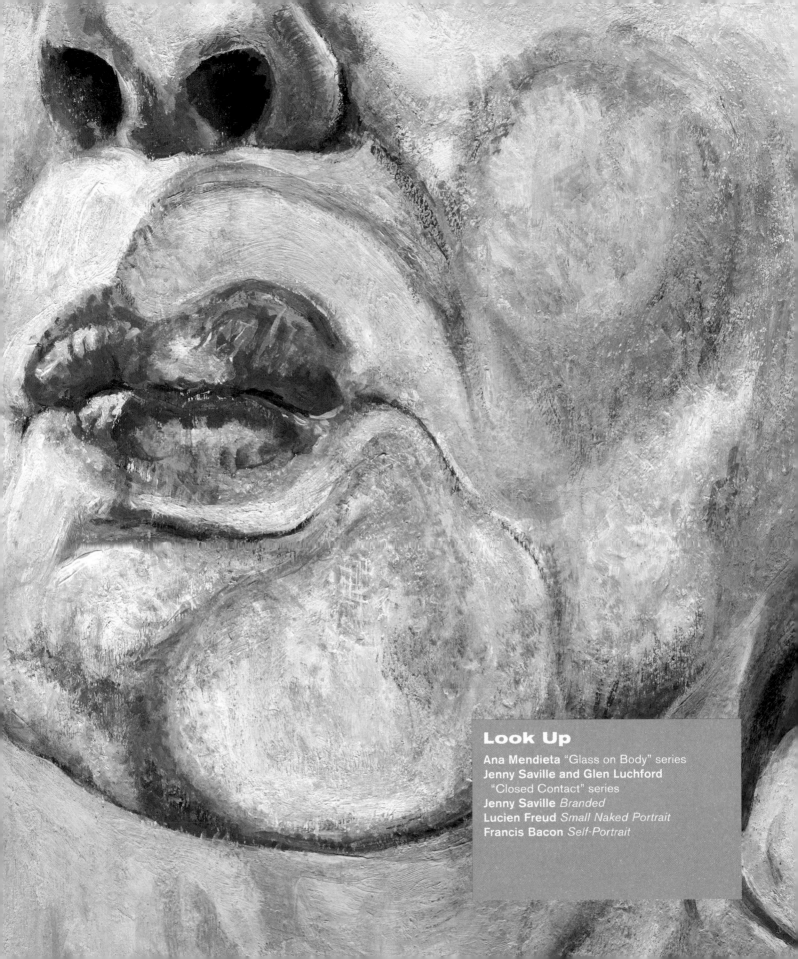

Look Up

Ana Mendieta "Glass on Body" series
Jenny Saville and Glen Luchford
"Closed Contact" series
Jenny Saville *Branded*
Lucien Freud *Small Naked Portrait*
Francis Bacon *Self-Portrait*

Juan Sánchez Cotán (1560–1627) was a Spanish Baroque painter who painted a number of still-lifes in the Bodegón tradition. The term comes from the Spanish word *bodega*, meaning "pantry" or "wine cellar," and referred to the everyday objects depicted; often a collection of foods or kitchen utensils placed on a stone slab.

Suspense

The objects were lit with a strong directional light and placed in front of an intense black background, creating a dramatic effect of high contrast. Cotán was famous for his simple, but exquisite compositions of fruit, vegetables, and game. During this period, food was often suspended from string to prevent it from rotting, and Cotán utilized this approach in his paintings. He hung fruit and vegetables at different heights, to create a sense of harmony and balance.

Look Up

Fischli/Weiss
"Equilibres" series
Louise Bristow
The Black Square
Jan Davidsz de Heem
"Vanitas" still-life
Vladimir Tatlin
Tatlin's Tower
Juan Sánchez Cotán
Still-Life with Quince, Cabbage, Melon, and Cucumber

Method

The contemporary Swiss artists Peter Fischli (b. 1952) and David Weiss (1946–2012) produced a series of photographs called "Equilibres" that were made of precariously balanced objects. These forms were brought together to create a sense of tantalizing equilibrium and photographed just at the point before the sculpture collapsed.

1. You are going to make a painting from a photograph of a sculpture that you will make, using everyday objects. Gather lots of different objects from around the house.

2. Now construct your precarious sculpture using the objects. You can vary the size and form of the objects. Try to find shapes that work well in juxtaposition with each other. Take time to compose your setup, and don't worry if it falls apart. Rearrange the objects and keep going until you find a perfect balance. The more unstable the better—it only has to stand long enough for you to quickly take a photograph of it.

3. Keep your camera close by, ready to photograph the sculpture before it collapses in a heap.

4. Once you are happy with your photographs, you can set about painting the construction.

5. The artist has used stretched watercolor paper and gouache to make the painting shown here.

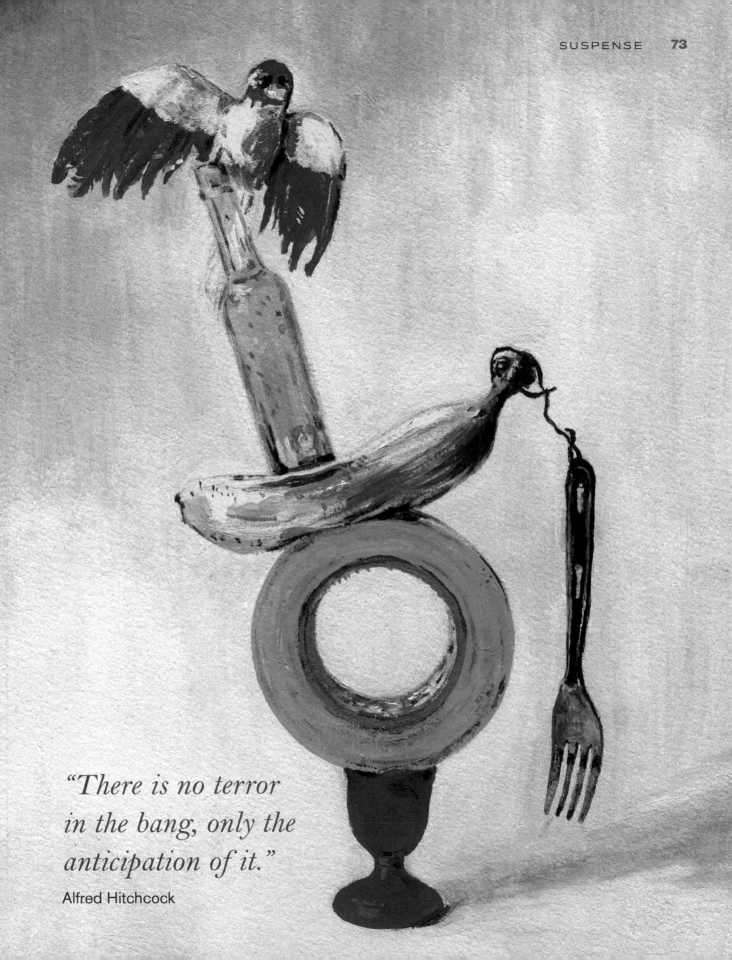

"There is no terror in the bang, only the anticipation of it."
Alfred Hitchcock

Watercolor is temperamental, a bit like a child; sometimes it is biddable, other times the paint develops a mind of its own and creates unpredictable results. This makes it an exciting medium to work with. Sometimes the surprising results are better, more magical than you could have expected, sometimes not. However, it is undeniably creative and fun to work with unpredictability.

Watercolor: The Art of
Surprise!

Here the blue and red have merged softly in what is called a graduated wash. The paper was wet when both colors were brushed onto it.

This mark is called a back run—it sometimes happens when working on wet paper. Some artists hate it and will do anything to avoid it, others love it and will try replicate it, and sometimes watercolor will just not do either.

Watercolor paint is a color or pigment mixed with a water-soluble binder or carrier. It's mixed with water to make the strength of color that you want, from glowing luminous colors, where the transparency of the paint with a little water added allows the white of the paper to shine through, to pale veils of subtle color mixed with more water than color.

Buy it in tubes, with a toothpaste-like consistency—the paint needs a little water added to make it workable; in pans or cakes—the pigment is dry and pressed into a container (it needs the addition of water to make it workable); or as an ink, which needs no water unless you want to make it paler.

It is the addition of water that makes the medium so unpredictable. The amount of water mixed with the paint, the wetness of the paper, the room temperature, and different pigments are all temperamental variables, causing different reactions. To understand watercolor, try experimenting with different colors, papers, and levels of wetness. You can use watercolor paints in a drier, less watery way where you have more control, or you can use watercolor with a lot of water, in the form of washes. As shown on these pages, you will have less control over the result, but hey, let go! And let the paint work its magic.

This textured appearance is called granulation. The pigment has dried into the little depressions in the paper; as with back runs, some artists love the effect while others try to avoid it. The rough texture of a paper or particular paints can both create this effect. Look at the information on the paint label before you buy, as most manufacturers say if a pigment has this property.

Method

1. Use 140lb rough watercolor paper cut into several equal-sized pieces. Make sure you cut enough that you will not be reluctant to experiment and make mistakes.

2. Using a watercolor palette, saucers, or jar lids, mix three or four colors of your choice in each with water, so they are a milky consistency. You can use a single color from the tube or you can mix colors together.

3. Using a large watercolor brush (no. 10–12) wet the surface of the papers with clean water, wait a couple of minutes for the water to be absorbed slightly, then apply one color in different shapes on each sheet of paper. Try spots, stripes, random swirls, or simply drop/blot the paint from a height.

4. Before the paint dries on some of the papers, add a second or even a third color, repeating the process of painting shapes. Watch how the colors merge or repel each other. Try tilting the paper at an angle and watch the colors dance around the paper.

5. On the remainder of the papers, let the first color dry, then try adding the subsequent colors— see the difference.

Don't worry about the result. You will find that you will love some of the results of both methods.

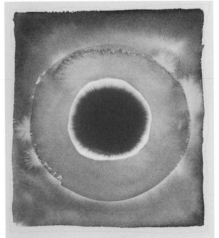

Bullseyes

Paint circles and rings on wet and dry paper, then paint subsequent colors over or around the first color wash, which has been allowed to dry to different degrees. Generally, a hard edge indicates the paper is dry, while a soft, blurred, or back-run edge shows the paper is damp and the pigments have run into each other. Try it and see if you can create both types of edge.

Look Up

Callum Innes *Vanadium Yellow/Red Violet*
David Austen *Papillon, Color Sketches*
Sophie von Hellermann *The Young Man and the Old Man and the …*
Lucia Nogueira *Abstract Responses: Untitled*

Look Up

Handprints In the Pech Merle caves, France
Blek le Rat *Computerhead*
Banksy *Laugh Now*
Jef Aérosol *Fernando Pessoa*
Shepard Fairey
"Obey Giant" campaign

Cut it Out

The earliest known examples of the use of stencils are in the French and Spanish Paleolithic caves. These hand stencils are believed to have been produced approximately 32,000 years ago by prehistoric artists spitting paint onto a hand held flat on the rock surface, and some were even made by blowing pigment through bones. The Egyptian, Greek, Roman, Chinese, and Japanese civilizations all used a form of stencil to reproduce images on wall surfaces or cloth, or for communication purposes. The Chinese invented paper around AD 105, and fully exploited its commercial use by producing stencils designed to be applied to wall surfaces and fabric.

During the Second World War, the Italian dictator Benito Mussolini used stencil portraits of himself on the streets of Italy to spread his fascist idealogy. Meanwhile the German White Rose group spread their opposition to the Nazis via the immediacy and anonymity of stencil art. Anyone armed with a stencil and spray paint can quickly and effectively convey their message on the street.

In 1961, the influential French street artist Blek le Rat (b. 1952) was fascinated by one of the Mussolini stencils he saw among the ruins on a trip to Italy. The image had greater resonance for him, as his father had been a prisoner of war in Germany during the Second World War. Ten years later, he was greatly influenced by a trip to New York, where he was exposed to street and subway graffiti art. It was years later that he decided to make his mark on the streets of Paris, by stenciling rats across the city. He said that "rats are the only free animal in the city." His work has greatly influenced his fellow street artists, like Banksy and Shepard Fairey.

The stencil design is drawn onto the cardboard.

The artist cuts out the stencil design.

A fully cut-out stencil.

The orange background color is sprayed first.

The artist sprays the first coat of black paint with even, sweeping movements.

A second and final coat is sprayed, 9 in. (23 cm) from the surface.

Method

1. Design a simple image that will work well in stencil form. You can draw your own image or use a photograph. You will need some thin, strong card to make your stencil, and a utility knife or scalpel to cut out your design.

2. Transfer your design by drawing onto the card, or draw your design on a separate sheet of paper and stick it to the card with spray adhesive.

3. Now place the card on a cutting mat and very carefully cut out your stencil. Remember that you are working with positive and negative areas. Whatever you cut away will be left as solid color.

4. When making a stencil, remember that your image should be one connecting piece of artwork.

5. Use another stencil if you are using different colors in the same design.

6. Mask out any areas that surround the stencil to keep the paint from escaping over the edges. This is called "overspray." To prevent "underdrip"—

where the paint bleeds under the stencil—lightly coat the back with a repositional adhesive spray.

7. Wear a protective mask and make sure that you are in a well-ventilated area or preferably outdoors.

8. Start to spray with even, sweeping movements approximately 9 in. (23 cm) from the surface. Spray from top to bottom and then upward again.

9. Leave your finished stencil to dry for about 15 minutes, then repeat the process if necessary. Carefully peel away the stencil to reveal your creation.

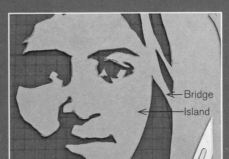

←Bridge

←Island

"Painting is by nature a luminous language."
Robert Delaunay

Light and luminosity have an inspiring and stimulating effect on the human psyche, and artists have always sought to find ways to capture the radiant qualities of light. "Glaze" is a term used generally in oil painting to describe the process by which a thin layer of transparent medium is painted over the surface of a painting. This gives a painting a richer luster and brilliance. This exercise will make you think about ways that you can use transparent light surfaces to create luminescent color.

Art of Glass

You are going to learn about how light reacts to, as artist Brian Clarke (b. 1953) puts it, "transmitted color rather than reflected color." Clarke is an artistic polymath who creates internationally acclaimed stained-glass designs for architectural projects, such as the Pfizer Building in New York; the Pyramid of Peace in Astana, Kazakhstan; and the Holocaust Memorial in Darmstadt, Germany. Clarke developed a unique glazed color process that bonds with architectural "float" glass. The color can be applied to large areas of the glass without having to resort to the traditional leading techniques. He believes that: "… people respond to beauty both in nature and in art. When it involves the passage of light, it is uplifting in a way that is incomparable."

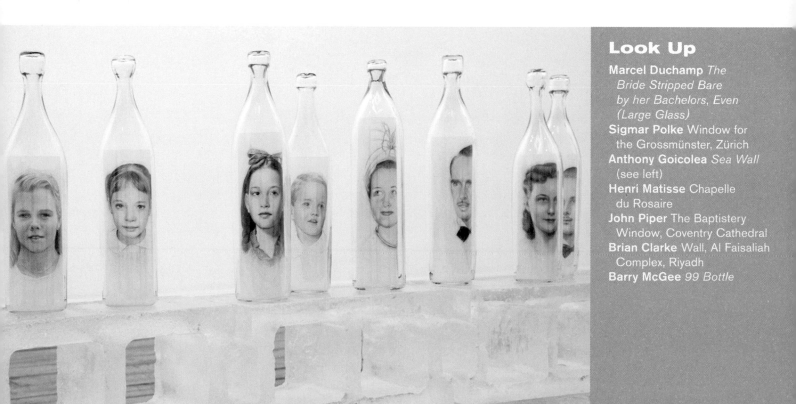

Look Up

Marcel Duchamp *The Bride Stripped Bare by her Bachelors, Even (Large Glass)*
Sigmar Polke Window for the Grossmünster, Zürich
Anthony Goicolea *Sea Wall* (see left)
Henri Matisse Chapelle du Rosaire
John Piper The Baptistery Window, Coventry Cathedral
Brian Clarke Wall, Al Faisaliah Complex, Riyadh
Barry McGee *99 Bottle*

Method

1. Go through the trash to find discarded glass jars and containers.

2. To prepare your glass surface, use a solvent (such as mineral spirits or denatured alcohol) to remove any grease or surface dust.

3. Glass paint is produced in two forms—water-based (nontoxic) and non-water-based (toxic). For this task it would be preferable to use the safer, water-based paint. It will also be much easier to clean your tools, and they will have a quicker drying time.

4. Natural hairbrushes and synthetic brushes are both suitable for painting onto glass. If you are using water-based paint, you can wash out your brushes very easily with soap and water.

5. Begin to carefully paint your design onto the surface. You can insert your non-painting hand inside the bottle, to secure and turn it. To achieve a lighter color, dilute the paint with water. Always use a palette to hold the paint; this will help keep your colors pure and unadulterated.

6. If you need to cover a large area of glass, try a technique called sponging. Dab the surface of the glass with a small sponge cube. The sponge will be less streaky and will give you a flatter color than a brush.

7. When you have completed your painting, you can protect your work with a coat of varnish. Glass paint varnish is available in a gloss or matte finish.

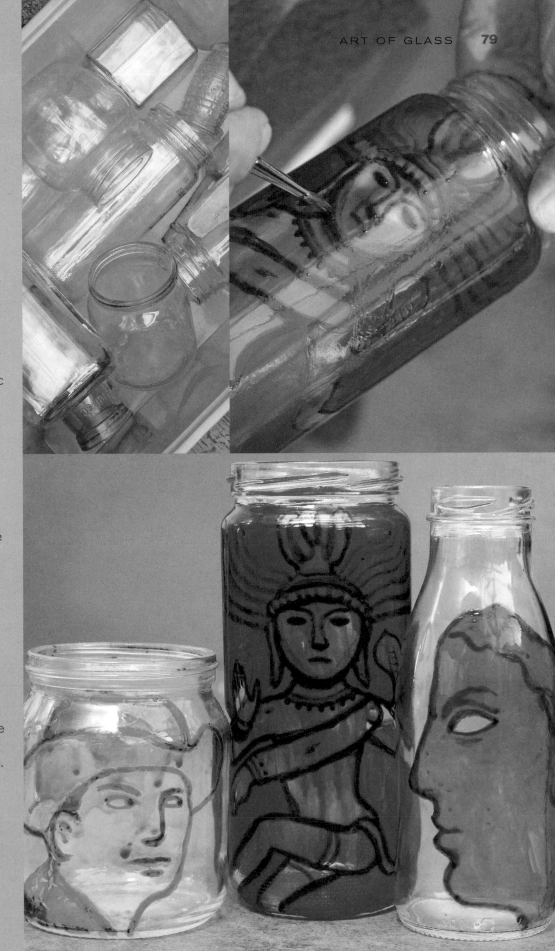

CHAPTER

Composition and Space

"Good composition is like a suspension bridge—each line adds strength and takes nothing away."

Robert Henri

The "Rule of Thirds" is a compositional device that involves superimposing a grid on an image and dividing the canvas equally into thirds, vertically and horizontally. Placing certain visual details at the focal points helps draw attention to them, creating areas of emphasis within the framework that balances with the remaining "quiet" areas.

Three is the Magic Number

There are certain sets of guidelines used by artists and designers to aid composition. The "Golden Section," for example, is based on a numerical principle in which a rectangle is divided so the ratio of its shorter side to its larger side is approximately 0.618. The ancient Greeks believed this calculation could be used to attain ideal proportions. During the Renaissance, artists adopted it as a compositional tool, and Leonardo da Vinci's "Vitruvian Man" illustrates the principle perfectly.

The Rule of Thirds is similar to the Golden Section, but the image is divided into thirds equally and the intersection points are closer together. It is a compositional principle intended, in general, to create a sense of balance and harmony. Your composition should, however, reflect a personal intention—you should, wherever possible, use your intuition to determine how to apply these rules. They are only guidelines and your final decision really depends on your own unique viewpoint.

Look Up

John Thomas Smith *Remarks on Rural Society* (illustrated book that defined a compositional rule)
Giorgio de Chirico *The Enigma of the Arrival and the Afternoon*
Edouard Manet *Music in the Tuileries Gardens*
John Constable *Harwich Lighthouse*

The Rule of Thirds is applied by dividing the height and width of the frame into equal thirds with your eye. Important elements of your painting can then be placed at the points where these lines intersect.

Method

1. Take your painting materials out with you and go for a walk, until you find a landscape or cityscape that interests you.

2. Look closely at the subject matter and paint it, applying the Rule of Thirds to make your composition.

3. Remember to consider elements such as color, tone, and dominant and subordinate areas in your composition.

4. Keep an open mind and try out different arrangements.

5. Move your viewpoint around and find how the dynamics of the scene change. You can create tension and excitement by breaking the rules. Use them as a yardstick and as a starting point from which to experiment and explore.

Taking Shape

Gary Hume (b. 1962) is a British artist who often paints simplified forms, composed with clearly defined negative and positive areas. Hume's paintings of hospital doors, *Girl Boy, Boy Girl*, were painted in household gloss on MDF and aluminum. He enjoyed the "modernist" clarity of these ordinary objects and felt the shapes should be painted in gloss, a paint similar to that used in hospitals.

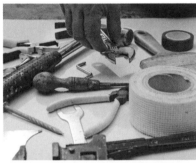

"I use household gloss ... the mundane stuff we all have in pots we all have under the stairs. But when you make a painting with it, it transforms itself from a mundane object into a beautiful one."
Gary Hume

Method

You are going to paint negative shapes. Many artists are inspired by the negative—the spaces not within, but without.

1. Look around the house for old and neglected cans of household paint. You are going to salvage the paint and think about how you can improve your painting skills by taking time to see the negative spaces.

2. Empty your toolbox to find interesting shapes.

3. Place your objects on a flat surface so that they create a kind of surface pattern.

4. Cover a board or canvas with a flat light color and then draw your pattern onto the surface with a brush or pencil. Now focus on the negative spaces (the shapes between the objects) and exclude the positive shapes from your mind. Begin to block in these shapes with a darker color.

5. When painting in this way, it will help you to think about painting more objectively. Detaching yourself from the actual objects will enable you to think about the relationship between them. Ultimately, it will show you that by emphasizing the negative space, you get a new appreciation of the subject of your painting.

Look Up

Gary Hume *Girl Boy, Boy Girl*
Henri Matisse *Icarus*
Patrick Caulfield *Pottery*
Jean Arp *Configuration*
Edgar Rubin *Vase*
Michael Craig-Martin *Inhale (White)*
Jean Arp *Mustache Hat*

Narrative, or storytelling, has always been a part of the history of painting. The Renaissance artists undertook "history paintings," recording classical and biblical narratives.

Art of Storytelling

William Hogarth (1697–1764) was a great storyteller. His "A Rake's Progress" narrative of eight sequential paintings describes the gradual moral and physical decline of Tom Rakewell. His fictional character is a gentleman who inherits a fortune and squanders it away, leading him into debt, imprisonment, and finally insanity. In the nineteenth century, visual storytelling included not only depictions of historical events but also domestic scenes. The modernists, however, rebuffed narrative representation, and eventually, with the development of abstraction, it became unfashionable. Today many contemporary artists are returning to a narrative approach, using the methods and techniques of the past to communicate stories in a modern context. For example, Paula Rego (b. 1935) has taken inspiration from Hogarth's "Marriage à la Mode" series to create her own vision of a skewed and doomed arranged marriage, *The Betrothal: Lessons: The Shipwreck*. Rego challenges us to interpret her staged pictorial compositions. There is often a sinister undercurrent, an air of suspense. She leaves us in anticipation of what might transpire on the final page.

Method

Think of a story and interpret the tale as a series of paintings. Consider the elements of the story that are important to emphasize and compose your images in succession. This will help you to understand ways to convey a narrative through a progression of images.

Nick Higgins
Epic of Gilgamesh

Artist Nick Higgins was inspired to make a series of paintings referencing key scenes in one of the earliest surviving pieces of literature, "The Epic of Gilgamesh."

Gilgamesh Cuts His Beard

Gilgamesh

Gilgamesh in the
Carnelian Garden

Gilgamesh and Enkidu Fight the Winged Bull

Gilgamesh the King

Gilgamesh and the Onager Chariot

The Whore of Shamat

Gilgamesh and Enkidu Slay Humbaba

Look Up

Paula Rego (After Hogarth's "Marriage à la Mode" series) *The Betrothal: Lessons: The Shipwreck*

William Hogarth "A Rake's Progress" series, "Marriage à la Mode" series

Pablo Picasso *Guernica*

Leonardo da Vinci *The Last Supper*

John Everett Millais *Ophelia*

Francisco Goya *The Third of May*

Faith Ringgold *Tar Beach* (story quilts)

Gilgamesh and Enkidu Fight The Winged Bull

"At one side of my house in Malibu is the Pacific Coast Highway; at the other is the beach. I step out of my kitchen door and there, is the sea. So when I'm painting in my studio I am very aware of nature, in its infinity, and the sea endlessly moving."
David Hockney

Panorama

David Hockney prefers to use his memory to imagine and construct his landscape paintings. He also enjoys painting on a large scale. Although he embraces photography as a medium, he prefers to use preliminary sketches (at present drawn on his iPad) and his powers of recall to create his multi-faceted visions of his journeys. When Hockney lived in the Hollywood Hills, he repeatedly drove along Mulholland

Drive to reach his studio in Malibu. With his panoramic, narrative painting, *Mulholland Drive*, he visually describes the journey.

In this exercise you will look at painting as a form of panoramic narrative. You will look at a journey through a landscape or a scene and you will paint the view as a continual vision.

Method

1. Go out for a walk and take either a pocket box of paints or a box easel containing tubes of paint. You can tile sheets of watercolor paper together (up to eight) to make your long panoramic painting. Stick them together with masking tape on the back. This will make a long sheet of paper to paint on.

2. Find a panorama that has various landmarks, patterns, and textures. Now place your long constructed sheet of paper on the ground. First, sketch the horizon line with a paintbrush and then quickly mark out the scene, roughly breaking it into sections along the line.

3. Next fill in the details, incorporating the people, dogs, cars, and so on that may fleetingly appear in the scene.

Look Up

David Hockney
Mulholland Drive: the Road to the Studio
Edward Ruscha
Every Building on the Sunset Strip
Matteo Pericoli
Manhattan Unfurled
Zhang Zeduan The Beijing Qingming scroll
Utagawa Hiroshige III
Steam train between Tokyo and Yokohama, Bayeux Tapestry

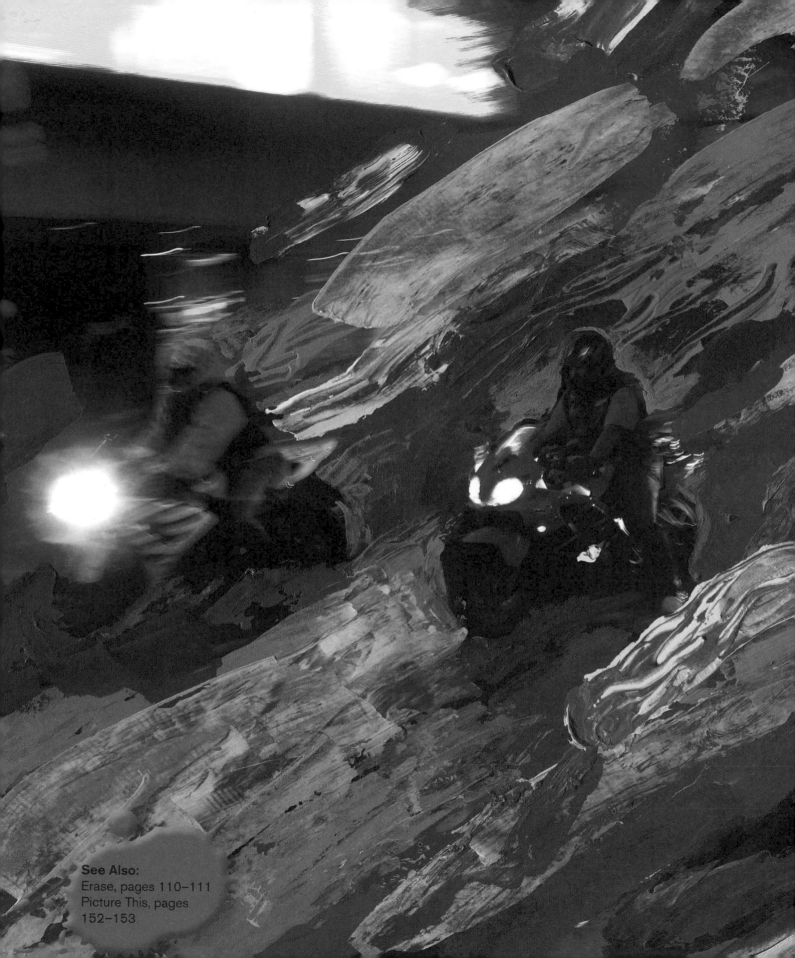

See Also:
Erase, pages 110–111
Picture This, pages
152–153

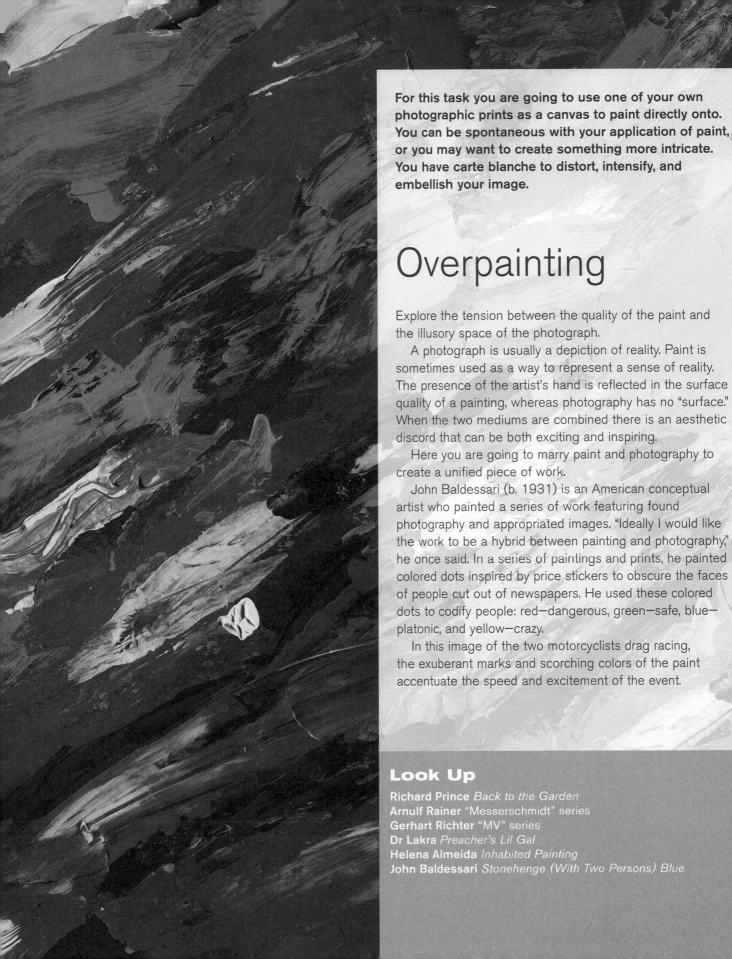

For this task you are going to use one of your own photographic prints as a canvas to paint directly onto. You can be spontaneous with your application of paint, or you may want to create something more intricate. You have carte blanche to distort, intensify, and embellish your image.

Overpainting

Explore the tension between the quality of the paint and the illusory space of the photograph.

A photograph is usually a depiction of reality. Paint is sometimes used as a way to represent a sense of reality. The presence of the artist's hand is reflected in the surface quality of a painting, whereas photography has no "surface." When the two mediums are combined there is an aesthetic discord that can be both exciting and inspiring.

Here you are going to marry paint and photography to create a unified piece of work.

John Baldessari (b. 1931) is an American conceptual artist who painted a series of work featuring found photography and appropriated images. "Ideally I would like the work to be a hybrid between painting and photography," he once said. In a series of paintings and prints, he painted colored dots inspired by price stickers to obscure the faces of people cut out of newspapers. He used these colored dots to codify people: red—dangerous, green—safe, blue—platonic, and yellow—crazy.

In this image of the two motorcyclists drag racing, the exuberant marks and scorching colors of the paint accentuate the speed and excitement of the event.

Look Up

Richard Prince *Back to the Garden*
Arnulf Rainer "Messerschmidt" series
Gerhart Richter "MV" series
Dr Lakra *Preacher's Lil Gal*
Helena Almeida *Inhabited Painting*
John Baldessari *Stonehenge (With Two Persons) Blue*

Arrivals

The next time you are picking up someone from the airport, get there a lot earlier than you need to and paint the comings and goings.

An airport is a wonderful place to see a diverse group of people. Unless you live in an incredibly cosmopolitan community, you will never come across as many people of different nationalities in one place. The outpouring of emotions from people greeting their loved ones is contrasted with cab drivers holding up signs with the names of their clients.

Look Up

Marlene Dumas *Suikerspook* (see below)
Mark Wallinger *Threshold to the Kingdom*
Rembrandt van Rijn *Young Woman Sleeping*

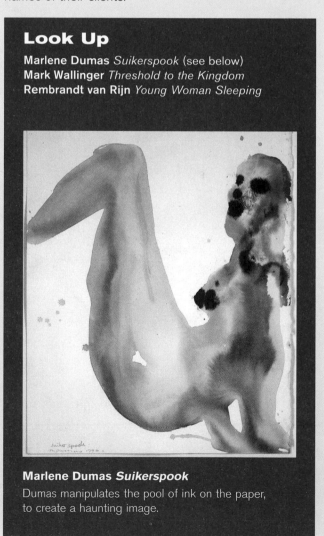

Marlene Dumas *Suikerspook*
Dumas manipulates the pool of ink on the paper, to create a haunting image.

Method

1. Use a letter-paper-size watercolor sketchbook with India ink and a small bottle containing water for washes. Don't over-complicate things by having too many brushes and pots of different-colored inks. Keep things simple by having one pot of ink and a couple of brushes. Airports are busy places, so it won't be appreciated if you have a more complicated setup.

2. Have a look around and, once you have spotted someone to paint, you will have to work fast. Move the paint around the paper, making quick gestural marks. You can fill in any details once you have rendered the main figure. Some people will move too quickly for you to capture them, so adjust your brushstrokes to suit. Every now and then, take a break from chasing people with your brush, by painting others who are stationary. Go to a café or bar, have a drink, and paint the other clientele.

During his childhood the artist Chuck Close (b. 1940) spent hours drawing and painting as an escape from severe dyslexia and a neuromuscular condition. In addition to these problems, he also suffers from prosopagnosia, or "face blindness." To overcome these problems, he paints his "heads" (as he refers to them), or portraits, as a recognition strategy; an aide-mémoire. He uses a grid on a photograph to transfer the image onto a large canvas. Breaking the image into manageable sections on a grid makes "this more overwhelming problem into thousands of little more solvable problems."

Close-up

Home in on a section, then divide into nine.

Paint each square separately.

For this exercise you are going to paint a picture in small sections that will build into a bigger picture.

Method

1. Collect a number of objects, household or otherwise, and compose them in front of you on a table or on the floor.

2. Now take a photograph of your composition.

3. Home in on a section of the image. If you wish, it can be an extreme close-up, where the objects are unrecognizable. To make things easier, you can take a photograph of your close-up. Now break up your cropped image into nine squares by placing a grid over the top of the image.

4. Isolate each square and think of them as nine completely separate paintings.

5. Use acrylics to paint each of the nine squares separately.

6. Once completed, place the individual paintings down on the floor and piece them together like a jigsaw puzzle. The final image will probably misregister and the tones may be slightly disconnected, but this gives a certain tension to the piece. By studying cropped sections you will learn about composition, texture, and shape.

Look Up

Chuck Close *Big Self-Portrait*
Paul Cézanne *Mont Sainte-Victoire*
Georges Seurat *The Couple*
Roy Lichtenstein "Haystacks" series
Sigmar Polke *Rasterzeichnung* (portrait of Lee Harvey Oswald)
Vic Muniz *Self-Portrait*

"I make a face into a landscape and I journey across that landscape like Gulliver's Lilliputians, crawling along the face of a giant."
Chuck Close

Piece them together like a jigsaw puzzle.

CHAPTER

Pattern and Texture

"Art is pattern informed by sensibility."
Herbert Read

Method

1. How do we interact with our habitat? Do we feel conspicuous or hidden, blending insignificantly into the background? We often overlook the everyday but it can be extremely stimulating to observe and respond to the more mundane aspects of the world that we live in.

2. Gather a number of photographs taken from a walk around your immediate environment. Look for patterns and textures—they can be man-made or natural. Bring your photographs together and identify the basic patterns.

3. Select the strongest elements in each photograph. Turn the patterns into simple flattened shapes, and collage them together to create an urban camouflage.

4. Stretch some paper on a board or a hard surface, as this will keep it from wrinkling and the final painting will remain flat.

5. Use gouache for this exercise, as it allows you to paint clean, flat, opaque colors. Gouache has a much higher ratio of pigment to water and is therefore heavier and less transparent than watercolor. Remember that when you apply gouache, the lighter tones will dry darker and darker tones will dry lighter.

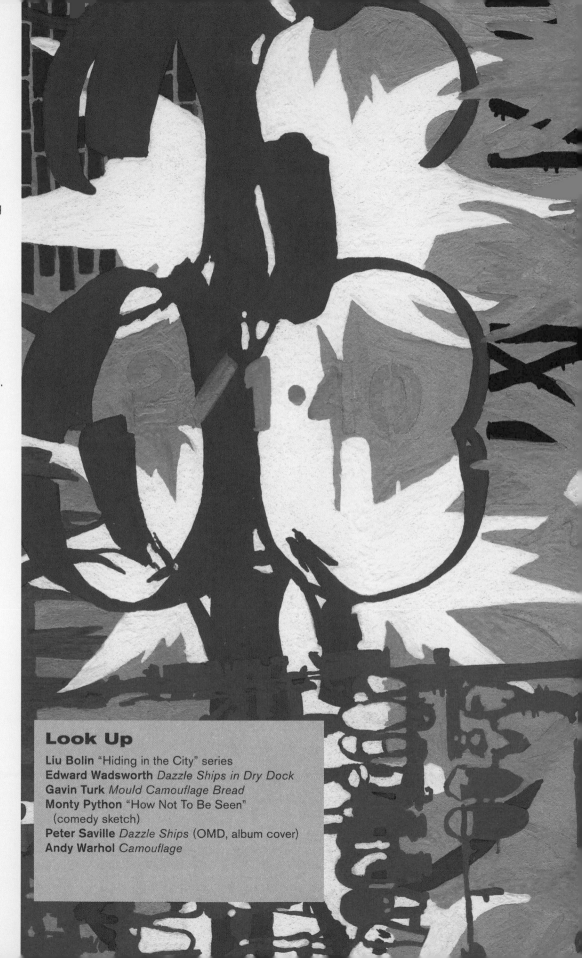

Look Up

Liu Bolin "Hiding in the City" series
Edward Wadsworth *Dazzle Ships in Dry Dock*
Gavin Turk *Mould Camouflage Bread*
Monty Python "How Not To Be Seen" (comedy sketch)
Peter Saville *Dazzle Ships* (OMD, album cover)
Andy Warhol *Camouflage*

"The Camoufleur ... must leave no clues for the detective on the other side in what he designs or executes, and he must above all things be resourceful. But his imagination and inventiveness should have free play."

Solomon Joseph Solomon

Camoufleur

"Camoufleur" was a term originally given to an artistic or scientific expert enlisted to design French military camouflage during the First World War; it had been recognized that concealing military equipment and personnel would be a great advantage. These specialist military units were adopted by other countries during the Second World War. The many artists who became Camoufleurs included Jacques Villon, André Mare, Arshile Gorky, László Moholy-Nagy, and Ellsworth Kelly.

Also during the First World War, Lieutenant Commander Norman Wilkinson of the British Admiralty came up with a radical concept for the camouflage of ships. Rather than render them invisible, the idea was to baffle the enemy using a distorted pattern painted all over the ship. Eighteen artists, known as the "Dazzle Section," worked on the project from the studios of the Royal Academy of Arts. Their designs drew heavily from Cubist principles, and were painted on 4,400 ships.

Today, artists are still interested in the concept of disguising and concealing. Beijing artist Liu Bolin (b. 1973) produced a series of works entitled "Hiding in the City." Bolin produces photographic images of himself "painted" into urban locations. He stands for long periods of time (up to a day) and, with the help of his assistants who painstakingly paint his clothing and body, he

disappears seamlessly into the background; a ghost-like apparition. He calls this process "invisibility." He dissolves into city landmarks such as the New York Wall Street bull, the Ponte di Rialto in Venice, and a London telephone booth, and has collaborated with artists as diverse as French graffiti artist JR and fashion designers Jean Paul Gaultier, Valentino, Lanvin, and Missoni. Bolin is inspired by the traditional Chinese philosophy of Taoism, describing his work as a "unity of man and nature." His sociopolitical themes serve to highlight the unsettled relationship that artists have with their physical environment.

Become a Camoufleur and create an urban camouflage design. Look at your surroundings and focus on the abstract shapes and patterns around you.

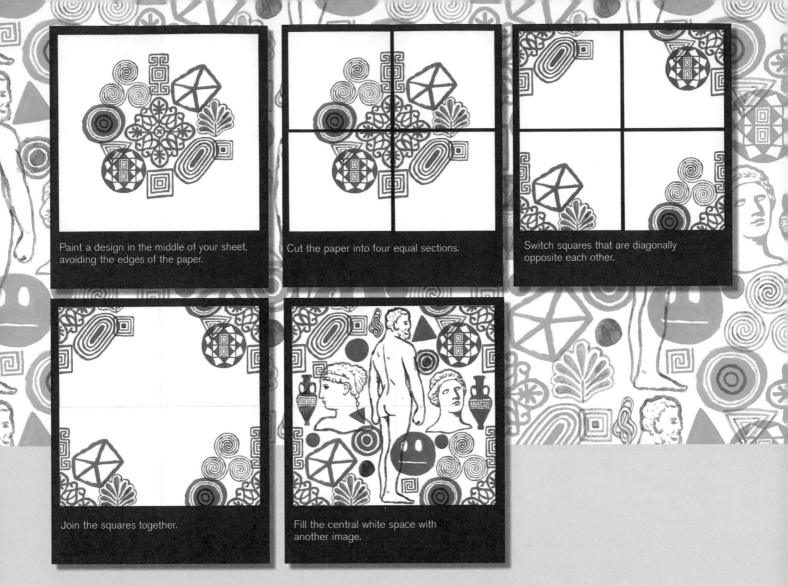

Paint a design in the middle of your sheet, avoiding the edges of the paper.

Cut the paper into four equal sections.

Switch squares that are diagonally opposite each other.

Join the squares together.

Fill the central white space with another image.

The Chinese invented wallpaper in the form of decorated rice paper around 200 BC. Wallpaper came to Europe in the sixteenth century, replacing expensive tapestries. Less wealthy folk pasted woodblock-printed papers on their walls. In the 1760s in France, Jean-Baptiste Réveillon (1725–1811) produced highly sought-after wallpaper designs: Marie Antoinette hung them on the walls of her apartments at Versailles. However, his factory was burned down during the French Revolution in 1789.

Repeat After Me

Wallpaper was seen as the preserve of the wealthy, and it wasn't until the 1800s that this was challenged. Mechanization meant that designs could be printed onto rolls of paper rather than individual sheets and they became more widely available.

William Morris (1834–96) was an artist and designer who founded the Arts and Crafts movement. He established Morris & Co. in 1861, producing a range of original designs and art products inspired by nature. He believed that the home should be a beautiful and relaxed place, and that a sense of well-being came from owning and producing finely crafted goods such as textiles, stained glass, furniture, and wallpaper. Morris's abiding principle was to "have nothing in your houses which you do not know to be useful or believe to be beautiful." He believed that such goods should be accessible to all. He was highly skeptical of the new mechanical production techniques, and saw them as morally corrosive and bad for the soul. His original wallpaper designs used traditional woodblock printing techniques. His flat, decorative patterns

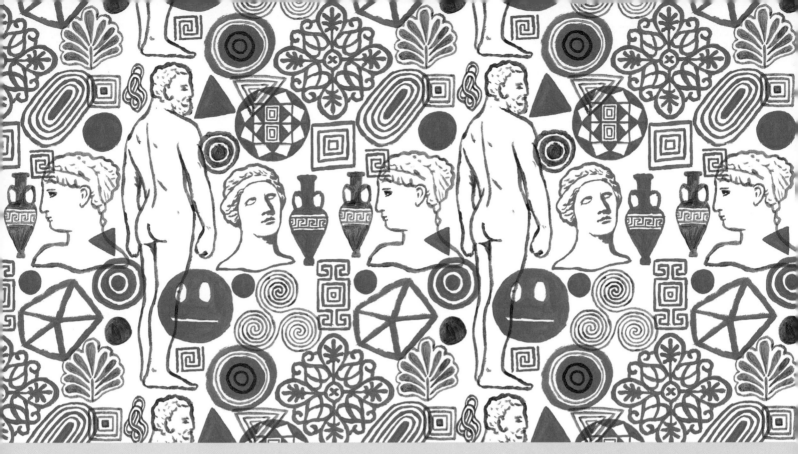

> *"Whatever you have in your rooms, think first of the walls;*
> *for they are that which makes your house and home."*
> William Morris

were inspired by natural forms and designed to complement the interior space. Regarded as an arbiter of good taste, his theories influenced designers and craftsmen then and now.

In the twentieth century, artists as diverse as Henri Matisse, Lubov Popova (1889–1924), and Andy Warhol (1928–87) produced wallpaper designs. In complete contrast to William Morris, Warhol embraced the idea of modern printing methods. Images such as *Cow* and *Mao* were never intended for commercial reproduction, but they reflect his trademark style.

Contemporary artists and designers have also recognized the potential of wallpaper. Damien Hirst (b. 1965) produced an intricate repeat design derived from his dead butterfly work.

Method

1. The term "wallpaper" is now also used to describe the background image used on a screen. Here you will create a seamless repeat pattern to decorate your computer screen. If you want to create a more expansive design, you can design wallpaper for your room. There are many digital printing companies that can turn your designs into rolls of wallpaper.

2. You will need a sheet of heavyweight paper, a pair of scissors, and any paint that dries quickly, such as acrylic, gouache, or watercolor.

3. Make sure the sheet of paper is no bigger than your scanner. Cut the paper into a square. Now paint a design in the middle of

the sheet, avoiding the edges of the paper.

4. When you are happy with the design, cut the paper into four equal sections.

5. Now switch the squares that are diagonally opposite each other.

6. Join the squares together with tape on the reverse side of the image.

7. Fill the central white space with another image.

8. Finally, scan your finished painting and tile your image digitally.

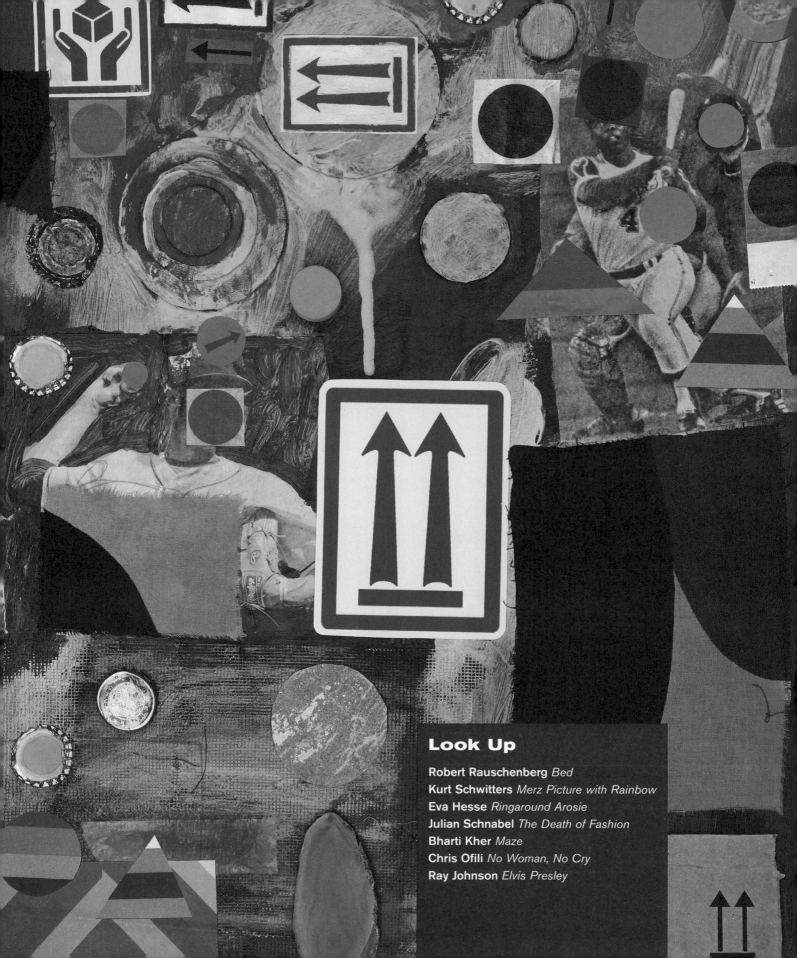

Look Up

Robert Rauschenberg *Bed*
Kurt Schwitters *Merz Picture with Rainbow*
Eva Hesse *Ringaround Arosie*
Julian Schnabel *The Death of Fashion*
Bharti Kher *Maze*
Chris Ofili *No Woman, No Cry*
Ray Johnson *Elvis Presley*

Incorporating collage into your work is a great way to add interest and different surface qualities to your paintings. There is a strong tradition of artists using found objects in their work. In 1917, Marcel Duchamp (1887–1968) famously used a porcelain urinal in his seminal piece, *Fountain*. Chris Ofili (b. 1968) included elephant dung in some of his early work, using the decorated spherical shapes to prop up his large canvasses; one is used to depict a breast in his controversial painting *The Holy Virgin Mary*.

Upcycle

The artist Robert Rauschenberg coined the term "Combines" to describe the influential body of work that he made in the period from 1953 to 1965. The pieces were a combination of painting, collage, and assemblages of everyday found objects. These mixed-media works blurred the lines between painting and sculpture by incorporating bold painterly splashes with various materials, including stuffed birds, doors, fabric, and Coca-Cola bottles. They were also a stylistic marriage of the painterly qualities of Abstract Expressionism with Pop Art motifs.

Method

1. Root around in your trash to find various materials to collage. Grab anything that you can—you can edit later. Use PVA glue to stick them down onto a thick piece of card or wooden board that has been primed with gesso.

2. Images cut from a newspaper or magazine can dictate the theme. For example, you might want to celebrate or even make fun of a movie star or politician. Or, take a purely decorative approach and just enjoy the juxtaposition of materials. It's up to you—there are no rules. Experiment with a broad range of textures and shapes. See what works and what doesn't and use successful elements again.

3. Compose your piece by placing some of your gathered materials onto the board. Cut them up and move them around until you are happy with your composition. Here, the cardboard circles, some bottle tops, and a piece of gauze were stuck down first, to make a base layer.

4. Prime these first collaged elements with gesso and, once this is dry, you can paint a background color with acrylic paints. You can then stick down the second batch of collage elements. Brush the PVA glue on the back and front of your materials (it will dry transparent). The newspaper cutouts, fabric, and more bottle tops were used in the second stage of this collage. The board can then be painted and new collage elements integrated by using more paint. Once finished you can seal it with varnish or a thin layer of PVA. You have now made a piece of upcycled art.

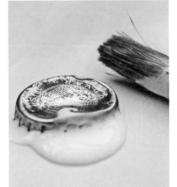

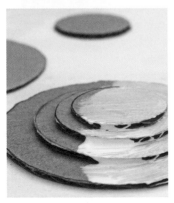

John Piper (1903–92) was an artist known for his atmospheric depictions of churches, castles, monuments, landscapes, and ruins. He was appointed official British War Artist in World War Two (1940–44).

House of Wax

Piper painted images of destruction, including Coventry Cathedral, which was bombed during an air raid in 1940. To add texture to his moody, atmospheric ruins, he used a number of mediums including collage, watercolor, gouache, and pen and ink. He described his work as a representation of "pleasing decay." Piper experimented with a variety of techniques, one of which involved wax resist. Frank Auerbach is renowned for his thick impasto oil paintings. Living in postwar London, he was fascinated by the many building sites that accompanied the rebuilding of the bombed-out structure of the City of London. Like Piper, he painted images of destruction, but he was really interested in depicting the process of regeneration on construction sites.

Find a decaying building, a demolition site, or a ruined piece of architecture, and apply the wax-resist technique to recreate the variety of marks and textures that you see.

Method

1. Lightly sketch the basic structure of your building/demolition site with a pencil on thick watercolor paper.

2. It is preferable to stretch your paper so that you can apply as much water as necessary to the paper's surface.

3. If you want to leave pure white marks and textured areas, use a white candle, crayon, or pastel. It will be difficult to see exactly where you are applying your marks, when using white, but if you tilt your board directly toward the light you will see the sheen reflected on the wax.

4. Use a wax crayon to roughly block out the sky. Apply a wash over your drawing with watercolor paint. Where the wax is applied, the

watercolor will be repelled and the paint absorbed around it. Let the paint dry thoroughly. Because you have stretched your paper, it should dry perfectly flat.

5. You can also build up areas with colored wax crayon, or scratch into the wax to create more detailed textures.

Look Up

John Piper *Coventry Cathedral*; *Poelfoen*
Peter Doig *Pond Life*
Frank Auerbach *Oxford Street Building Site*
George Hendrik Breitner *A Building Site*

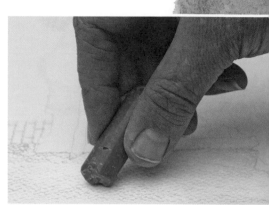

A blue wax crayon is used to roughly block out the sky.

The artist applies a wash over the wax drawing with watercolor paint.

Here the artist begins to build up areas with wax crayon, and scratches into the wax surface to create more detail.

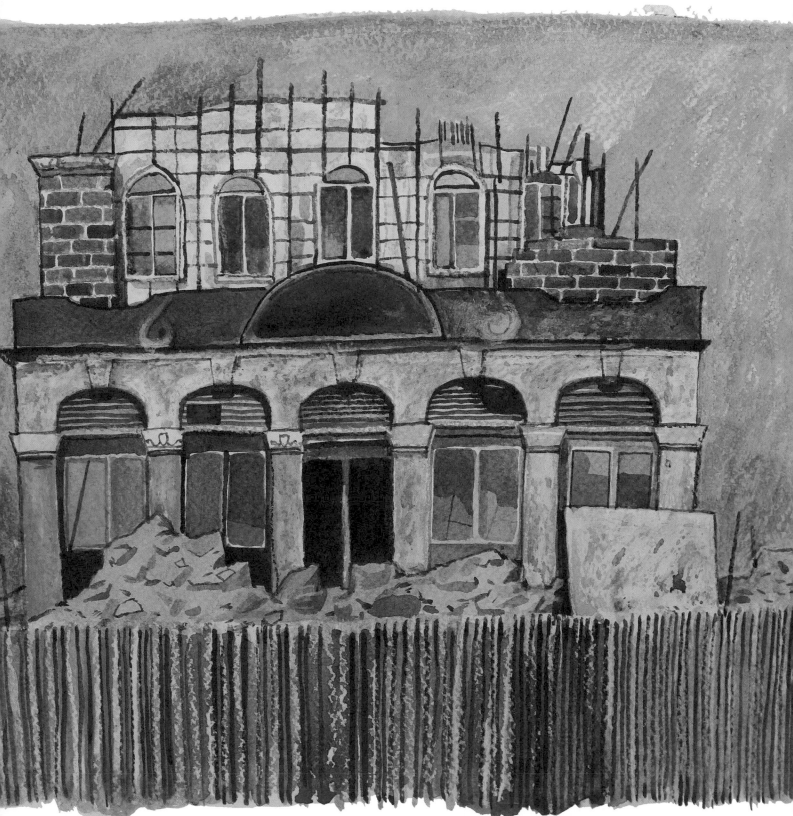

"Bomb damage has revealed new beauties in unexpected appositions."
John Piper

You are now going to use a combination of techniques to create texture and form.

Can You Feel It?

When you look at any subject you can see that it is a visual synthesis of color, texture, and form. You are going to discover and explore a number of methods for representing an object in different ways.

Adding texture to your painting gives it a sense of character. It can be created using a brush, along with various other tools, including palette knives, sponges, cardboard combs, and bubble wrap. An understanding of textural painting techniques can enliven and enhance your work.

Experiment with anything you can find to create interesting textures.

Creating Textures

Stippling
Build up tone with tiny marks. Georges Seurat's pointillist paintings were created using a series of small dots.

Hatching
Hatch a network of painted lines that together build up tone. The Italian masters often used hatching techniques.

Scumbling
Paint an undercoat and then apply a thin coat of a lighter color over the top. This will give a softening effect.

Look Up
Robert Rauschenberg
Winter Pool
Julian Schnabel
Oar: For the One who Comes Out to Know Fear
Ashley Bickerton
White Head I
Lee Krasner *Noon*
Antoni Tàpies *Creu I R*
Jackson Pollock
Summertime: Number 9A
Wilhelm Sasnal *Forest*

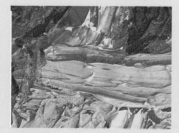

Scratching
Scratch into wet paint with a sharp tool. Look at Edgar Degas' *Races at Longchamp* paintings.

Impasto
Build up thick layers of paint. Look at the work of Vincent van Gogh, Frank Auerbach, Karel Appel, Leon Kossoff, Willem de Kooning, Lucien Freud, and Chaim Soutine.

Combing
Drag a comb or other tool with teeth across wet paint.

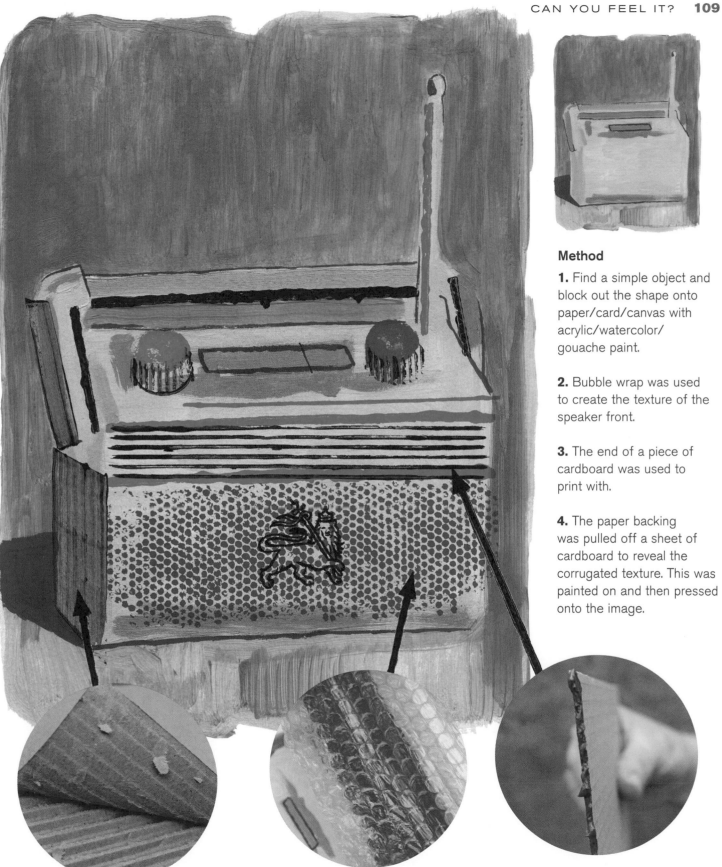

Method

1. Find a simple object and block out the shape onto paper/card/canvas with acrylic/watercolor/gouache paint.

2. Bubble wrap was used to create the texture of the speaker front.

3. The end of a piece of cardboard was used to print with.

4. The paper backing was pulled off a sheet of cardboard to reveal the corrugated texture. This was painted on and then pressed onto the image.

"Only the hand that erases can write the true thing."
Meister Eckhart

A collection of discarded magazines and newspapers.

Masking fluid is painted onto the image to block out the significant shapes.

The masking fluid is carefully peeled away to reveal the image beneath.

In the early 1950s, Robert Rauschenberg (1925–2008) was moving ever closer to his idea of minimalist purity. After completing his "White Paintings" he decided to take things one stage further.

Erase

Rauschenberg approached Willem de Kooning, the Abstract Expressionist painter, who in turn gave him unrestrained permission to delete one of his drawings. Over a period of time, Rauschenberg meticulously removed the original image using a number of erasers, creating a completely new work of art. Jasper Johns described this process as a form of "additive subtraction." Fifty years later, American artist Ellen Gallagher (b. 1965) began to appropriate images of "wig ladies" and black cosmetic advertisements from the black lifestyle magazines of the 1940s to 1970s. She placed a number of the images within a large grid and added modeling clay to specific areas of the portraits. Her aim was to redress an "anxiety about identity and loss."

She felt that through the process of canceling out and highlighting areas of these images, she could liberate them from the constraints of the past.

Look Up

Ellen Gallagher *Deluxe*
Robert Rauschenberg
 Erased de Kooning Drawing
Mishka Henner *The Transparently Absurd ...
 Canal Street*
John Baldessari *Frames and Ribbon,
 National City, Stonehenge (with
 Two Persons)*
Ignasi Aballí *Correction*
Alecshao Pochoir *Erased Lord*
Jean-Michel Basquiat *Anti Product
 Baseball Card*
Matt Bryans *Untitled
 (Erased newspaper cuttings)*

Method

1. Look through discarded magazines or newspapers and find an image or images that you can paint on, to remove areas of the image. Old knitting patterns and craft magazines have been used for this exercise.

2. Look at areas within your image that you would like to focus on and block out.

3. Use masking fluid to block out the shapes and areas that you want to keep. If you can't find any masking fluid, you can carefully paint around the exposed area.

4. Now paint your image. Once the paint is dry, carefully peel away the masking fluid to reveal the image. The areas that you have highlighted will now be revealed, and the negative space will appear as a block of color. As Josef Albers put it, "Minus=Plus."

5. If you wish, several images can be pieced together to produce a unified composition.

"If you have a square scarf, you don't wear it as a square, you wear it folded up, and therefore you must think of it as two or four triangles—always getting different results."
Tom Heron

Smooth as Silk

The history of painting onto silk dates as far back as the Mughal (Pichwai) silk paintings of India (made between the sixteenth and the eighteenth centuries). The detailed paintings depicted scenes of the Muslim conquerors of India and were often painted in miniature, directly onto silk.

Patrick Heron (1920–99) was an English abstract painter who began his career as chief textile designer for his father's silk scarf company, Cresta Silks. His commissioned designs, such as Melon, Amaryllis, and Aztec, were block-printed onto silk and bear a direct connection to his latter abstract works on canvas.

You are going to paint a silk scarf. Your design should consider the folds of the fabric and the way it will eventually be worn.

Look Up

Sonia Delaunay Scarves for London's Liberty & Co. (store)
Lucienne Day "Calyx" (fabric design)
Liubov Popova Textile designs
Elsa Schiaparelli "Cobalt Blue, Shocking Pink & White Silk Scarf"
Mughal Paintings on silk
Patrick Heron "Gourmet Scarf"
Damien Hirst "Pill Scarf"
Vivienne Westwood "Navy Skull-print Wool-blend Shawl" for Liberty & Co.

Method

1. Find a square of silk to use as your canvas. Silk often creases, so gently dampen the fabric to flatten out the wrinkles and then leave it to dry. You can then iron the fabric on a silk setting.

2. Now stretch the fabric onto a frame or an embroidery hoop, suspending it so that there is enough clearance underneath. When you are applying your fabric paint, it should not touch the flat surface beneath. You can use thumbtacks, Chinese suspension hooks, nails, or binder clips to attach the silk to the frame. You are aiming to get just the right amount of tension. Stretch the silk so that it is taut enough to paint onto but not so tight that it might tear.

3. Create your design, and either transfer it onto the silk with a light pencil mark or paint directly onto the silk with fabric paint. There is a variety of paints on the market. Some paints can be fixed using an iron, while others require a steaming process. It is probably best to use an iron-fix paint to begin with, as the fixing process is relatively uncomplicated.

4. To create clearly defined areas of color without the colors bleeding, you can use gutta to make outlines. Gutta is a resistant substance extracted from the Indonesian rubber tree, Gutta percha. Gutta can be painted or drawn onto fabric, and will create a barrier to keep the paint from running or merging into other colors.

5. If you are right-handed, begin to paint from left to right; vice-versa if you are left-handed. This will keep you from smudging and smearing your painting.

6. Think of your design as a folded garment—as Tom Heron said, "in two or four triangles."

7. When your design is complete, you can fix the fabric paint according to the manufacturer's instructions.

Here, the silk fabric is stretched onto an embroidery hoop.

The artist paints directly onto the silk with fabric paint.

The outline of the image has been constructed as a geometric pattern.

CHAPTER

Observation, Exploration, and Imagination

"Imagination will often carry us to worlds that never were. But without it, we go nowhere."

Carl Sagan

The Big Picture

"Avant" was a guerilla artist group that emerged in the early 1980s in New York.

Christopher Hart Chambers, Peter Epstein, David Fried, Marc Thorne, and Jed Tulman came together as a collaborative group of artists. They used cheap newsprint paper and painted mainly abstract works in oils and acrylics. At the time, the artists worked individually and anonymously on unique paintings and then joined forces to paste up their work in various locations in the city. Their aim was to distribute work throughout the cityscape, in a similar way to the commercial ad agencies, giving the public the opportunity to access and interact with visual art within their own environment. Avant utilized the street as a gallery space and forged the way for artists such as Shepard Fairey, JR, Bambi, and Ken Sortais, who showcase their work not only on the street but also in conventional galleries.

Method
Here you are going to think about painting on a large scale.

1. Produce a painting in an outside space, using spray paint, acrylics, or latex paint. However, don't get arrested—it's imperative that you gain consent from the owner of the space.

2. You can either paint straight onto your surface or paint off-site onto large sheets of paper that can then be tiled together and stuck with wallpaper paste.

3. The design can be abstract, political, or something that interacts with the space.

Look Up

Avant "Exact Change" show
Swoon *Sambhavna*
JR Kibera rooftops
Broken Fingaz *Sicilia Wall*
Ayrz *Ballad*
Eine *Vandalism*
Bambi *Amy*
TSS *Duke of Lancaster* 1956 steamer passenger ship docked at Llanerch-y-Mor, near Mostyn in north Wales

Street art can enhance and
enliven a drab urban environment.
The picture at left shows
the same building above—in
Shoreditch, London—repainted
with a different design.

"Speak softly, but carry a big can of paint."
Banksy

"Great things are not done by impulse, but by a series of small things brought together."

Vincent van Gogh

Some of the earliest examples of painted miniatures were found in medieval church manuscripts. They were illuminated capital letters that were sometimes adorned with tiny painted scenes or decorative motifs. The word "miniature" is derived from the Latin *minium*, which is the red lead pigment that was used to paint these illuminated letters.

It's a Small World

India has a great tradition of miniature painting, spanning from the tenth to the twentieth centuries. There were many schools of miniature painting, beginning with the Buddhist Pala empire (tenth to twelfth centuries), in which depictions of the Buddha's life were painted on palm leaves.

Miniature portraits were incredibly popular in Europe before the advent of photography in the nineteenth century. These intimate and often portable portraits first appeared in the French and English courts in the sixteenth century. Miniatures were usually painted in watercolor on vellum, which was traditionally made from calfskin treated to make a smooth surface to paint on. This was usurped by enamel paints on metal in

the seventeenth century, and then in the eighteenth century by watercolor on paper-thin sheets of ivory.

We are used to painting fine details on large paintings or scaling down images to fit into sketchbooks. However, this exercise is different in that you are going to make a painting that should be no bigger than 2½ in. (6 cm) square. Don't despair if you are short-sighted; a magnifying glass may come in very handy.

Your physical approach to painting will change when tackling a miniature. The tight movements of the brush will be dictated by small, subtle movements in your fingers and wrist. This contrasts sharply with the energy and the use of your whole body when making big gestural marks.

Actual size

This image is approximately 1⅓ x 1⅓ in. (3.5 x 3.5 cm). The elephant was sketched out with a size 1 brush in a dark paint. The larger areas were painted with a size 3 brush. The finer details were then added using a selection of size 0 brushes. Finally, additional blue tones were applied.

Method

1. Use a smooth, heavyweight paper with watercolor, gouache, or acrylic. Gather together some fine brushes ranging in size from 000 to 4. The size 000, 00, and 0 brushes will be used for the finest detail and the size 4 brush to cover larger areas.

2. Decide what you are going to paint—you can paint from life or from a photo. The artist here has squeezed one of the biggest creatures in the animal kingdom into a tiny frame. You might decide to paint an insect or a small object, or it could be a detail of something bigger. It's entirely up to you. However, don't paint a busy composition—it's best to keep things simple.

3. Now sketch out the image with a size 00 or size 1 brush and dark paint, making sure that your image is composed well within the confines of the small "canvas."

4. Paint larger areas with the size 3 or size 4 brush. Once you have covered these areas, you can work into the detail by using a selection of the zero-size brushes.

Look Up

Lisa Milroy *Small Objects*
Robert Hooke *Micrographia* (book)
Isaac Oliver *Elizabeth I*
Pablo Delgado "Little People"
Rachel Pedder-Smith
 Bean Painting: Specimens from the Leguminosae Family

You may want to use a magnifying glass to help you see what you are painting.

Sometimes you might be stumped for something new to paint. Why not choose a subject that you really like? Perhaps you collect something: pebbles, ceramics, toy cars, tickets. Do you take lots of pictures of friends and family? Why not document them in paint instead—it's far more personal and a great way to practice portraiture. Or do you like candy? You may be attracted to the challenge of painting shiny or transparent wrappers.

Take a Leaf

The artist Elizabeth Blackadder (b. 1931) has spent many years making studies of flowers and cats, with her subjects painted on a white background implying an analytical approach to each specimen. In David Hockney's "A Bigger Picture" exhibition at the Royal Academy in London in 2012, several rooms were dedicated to the study of different subjects by repeated observation and painting (they were "painted" on an iPad; see pages 68–69). He documented the subjects under different weather, light, and seasonal conditions; the repetition made for a powerful visual effect.

Think of a subject you would like to paint over and over again. Here, the artist chose leaves, and initially set about collecting different types, sizes, and shapes. The slight differences even between leaves of one species (such as the ivy shown here, for example), can be amazing. The painting was done over the course of several weeks, with each leaf being gathered on the day it was to be painted.

Each leaf was painted with a different approach, depending on the color and tone of the veins and markings.

Light veins and markings were created with an overall light wash, then masked to preserve them as darker washes were added.

Spots were achieved by painting a yellow wash over the whole leaf. The repeated spatters of masking fluid were allowed to dry and darker washes of paint and masking spatter built up.

Smooth transitions of color were dropped in wet-on-wet and the color allowed to bleed.

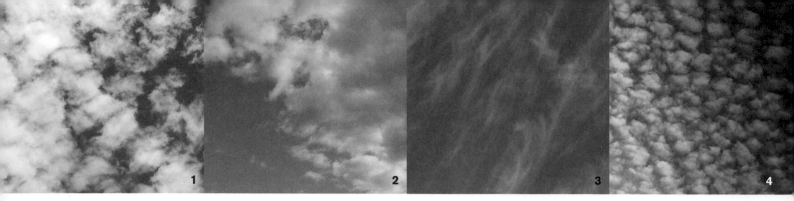

Head in the Clouds

In the nineteenth century, J.M.W. Turner (1775–1851) was fascinated by the sky and cloud formations. From an early age he closely observed the changes of light and the movement of clouds. During his lifetime, he made a number of spontaneous and experimental watercolor studies that he called "color beginnings." His intention was to capture the fleeting nature and fundamental qualities of clouds. Turner often used these preliminary sketches as an inspiration for finished paintings.

The "Cloud" series is a collection of absorbent cotton sculptures that imitate cloud formations made by the contemporary Brazilian artist Vik Muniz (b. 1961). These fluffy ethereal shapes such as a teapot, a cat, a snail, a man rowing a boat, and hands in prayer are then photographed to create, as he puts it, "low-tech illusions." Muniz is interested in exploring the viewer's self and imaginative projection with this body of work. As he says: "The watching of clouds, whether as a method of forecasting or a form of amusement has been going on for centuries: What one person sees as a chariot, another may see as a bear or as a gathering of angels. Visualization comes from within the observer."

Paint a selection of cloud formations, from literal to imaginative representations.

Look Up

J.M.W. Turner Studies of clouds, "color beginnings"
Vik Muniz *The Rower* ("Cloud" series)
The Orb "Little Fluffy Clouds" (song)
Leandro Erlich *Single Cloud Collection*
Alfred Stieglitz "Equivalents" series
Richard Misrach *Cloud #240*

René Magritte *Les Idées Claires*
Mantegna *Virtue Chasing Vice*
Alexander Cozens *"Pattern of Sky",1785* (18th century landscape painter drawing book series of schemata for clouds)
Berndnaut Smilde *"Nimbus 11"*

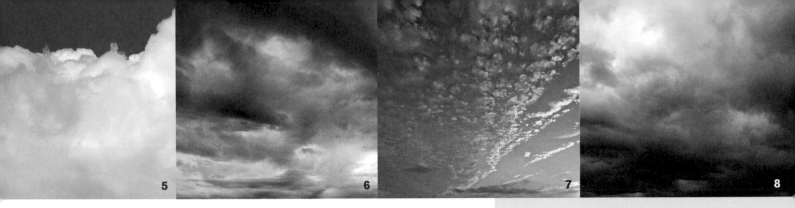

5 6 7 8

Some cloud formations that may inspire you

1. Altocumulus—a small band of patchy, fluffy gray clouds that may bring showers.

2. Altostratus—a thin, light gray sheet of clouds that may bring showers.

3. Cirrus—wispy, curly clouds.

4. Cirrocumulus—look like the rippling scales of a fish; a "mackerel sky."

5. Cumulus—puffy, cotton-ball clouds.

6. Cumulonimbus—thunderstorm clouds, that may form a line of towers. They can bring snow, hail, or heavy rain.

7. Stratus—a low, flat blanket of layered clouds.

8. Nimbostratus—a formless, uniformly dark gray layer of clouds. *Nimbus* is Latin for "rain."

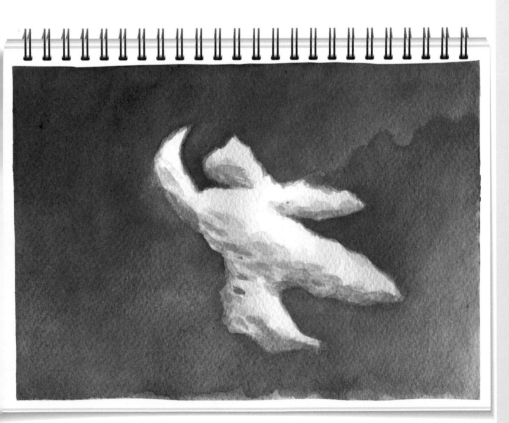

Method

1. You are going to make a series of "color beginnings"—spontaneous, experimental studies that will help to nurture your unconscious responses to this transient and ephemeral subject.

2. Lie back on the grass and look up to the skies. Study the cloud formations and then interpret and translate the pictures you see onto paper. Keep a small watercolor sketch pad or some small sheets of watercolor paper, a set of watercolors, and some brushes with you. The best brushes for watercolors tend to be animal-hair brushes (sable or squirrel), although you can try out different brushes to give you a variety of effects.

3. Wait patiently and have your paper and materials accessible so that you can respond immediately whenever an interesting cloud formation appears. Use the cloud shape as an inspiration to create an imaginative interpretation.

4. Try loose, wet washes: Drop watercolor onto wet paper and manipulate the paint, moving it around on the surface. Take full advantage of its serendipitous qualities. Watercolor can be unpredictable as a medium, so explore its flexibility. It can be applied in an opaque form or watered down completely to give it greater transparency.

Many artists paint from photographic sources, although this approach is often derided and deemed less worthy than painting from observation. To slavishly copy a photograph, especially when it's one that you have not taken, can be seen as an approach that is lacking in imagination. However, the practicality and convenience of using photographic sources are the main reasons why they are used.

Photo Opportunity

The Pop artists of the 1950s and 1960s celebrated the use of found imagery and used it copiously in their work.

The contemporary British artist Louise Bristow also uses found imagery as a key component in her work. She creates arrangements of models and collage elements that are reminiscent of miniature stage sets. These setups are then used to make paintings from. She never uses printouts taken from the Internet, as the texture and quality of the printed image are important to her. She roots around in thrift stores for old books and magazines as a source of inspiration for her work. She says: "There is a certain tension about using an original image which simply can't be printed again; it makes me use it carefully. The collage elements have a history and a strong identity, because they are original material dating from a particular period."

Your task is to make a painting from found imagery. Rather than copying a picture, try to manipulate it in an interesting way.

Possible approaches:

1. Rip up a photo and throw the pieces onto the ground. Now paint what you see.

2. Suspend a photograph in water and paint the contorted image.

3. Make a large painting from a tiny section of a photograph.

4. Cut and stick two or more different photographs together and paint the result.

5. Make a soft-focus painting by squinting at the photograph to eliminate all the fine details.

6. Fold an image into an accordion and paint the distorted image.

Green Ramp, 2012, oil on board

These pieces by the artist Louise Bristow were painted from constructed models made from collaged elements.

Look Up

Peter Blake *On the Balcony*
Gerhard Richter *Ferrari*
Mamma Andersson *Goodbye*
Shepard Fairey *Barack Obama/Hope*

Memorial, 2005, gouache on board

Idyll, 2005, gouache on board

Modern British Sculpture, 2009, gouache on board

Sometimes simple objects and belongings can take on a highly personal meaning. Artists such as Andy Warhol, René Magritte (1898–1967), and Philip Guston (1913–80) have all depicted shoes or footwear as a metaphorical way to express character.

These Boots Were Made for Painting

Vincent van Gogh painted many still lifes of shoes and boots during his time in Paris. In 1886, he bought a pair of worker's boots from a flea market and decided to paint studies of them. The discarded boots, with untied and twisted laces, appear as an autobiographical representation, weighted with meaning. Many feel that these studies of extremely familiar objects are symbolic of his inner conflict and life struggle.

We will never know what his true intentions were when painting these boots—perhaps they were just a good subject to paint in terms of shape, form, texture, and color. However, a pair of shoes can express an entire history, revealing the story of their owner's life.

These sandals have intense pure pigments on the straps to suggest leather; washes overlaid on the soles suggest wear.

Seen from Above
Draw the shoe (1).

Layer watercolor washes to the shadow areas, adding darker pigments and more washes to the darkest areas (2–4). Let dry between washes.

1

2

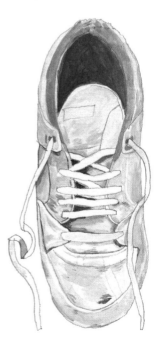

3

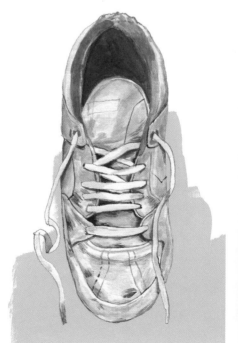

4

Find a pair of well-worn shoes, trainers, or any kind of footwear that you feel has character. The shoes might be worn out, weathered, or even caked in mud, but they should be interesting enough for you to want to capture them in paint.

Method

1. Use watercolor, gouache, or watered-down acrylic paint. Use a sheet of heavyweight watercolor paper or a stretched sheet of paper. Use a selection of brushes.

2. Place the shoes in front of you and observe them from a variety of different viewpoints. Take time to place them in relation to each other.

3. When you are completely satisfied with your composition and the viewpoint you're going to take, begin to sketch the outline of your shoe onto the paper with a pencil.

4. Look at the darker and lighter areas. Mix up a little color and begin to paint the shadows and darker tones. How are the shoes formed? Are there shadows within, and where does the light touch?

5. If the shoes have laces, for example, try to trace their path and gradually paint in the shadows to form the curves, loops, and twists. Use the white of the paper for some parts of the image.

6. Continue to look carefully at the shoes and try to express the life they have led in your painting. Use color, tone, and texture to enhance their very nature and character.

Look up

Vincent van Gogh
A Pair of Shoes
Andy Warhol
Diamond Dust
I. Miller *Shoes*
René Magritte
The Red Model
Philip Guston Various
boot and shoe paintings

Leave the paper white where the light hits the laces (5).

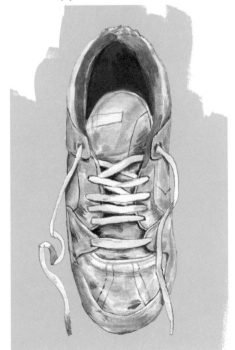

5

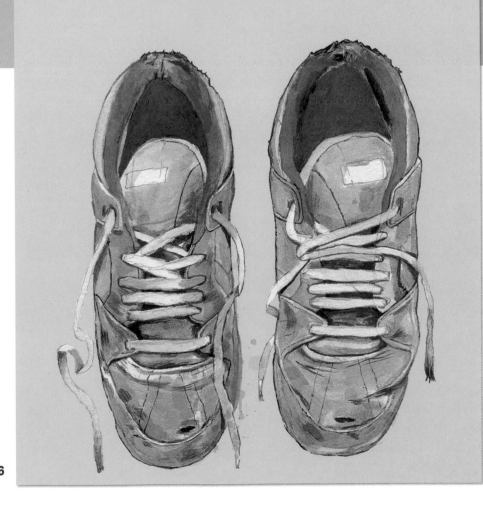

6

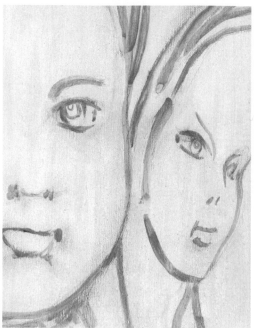 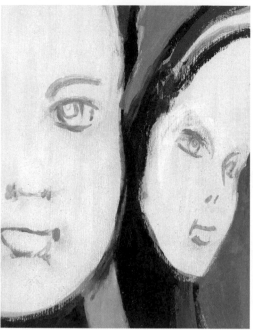 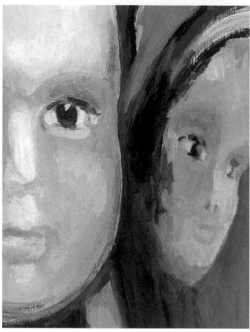

The composition is roughly sketched out onto a gesso-coated board.

The artist begins to paint the background by blocking in the greens, reds, and blacks.

Here the artist pays close attention to the light, shadow, color, and tone.

Mirrors have always been used symbolically as a means to attain spiritual reflection and self-knowledge. A mirror can be seen as a conduit that helps us to confront reality and see ourselves as we truly appear to others—warts and all.

On Reflection

In ancient civilizations, mirrors were precious possessions and were produced using highly polished metals. Reflections and mirrors are often referred to in Greek mythology. The Greek hero Perseus overcame the petrifying gaze of the gorgon Medusa by reflecting her image into a mirrored, metallic shield, and the cursed hunter Narcissus fell in love with his own reflection. The Baroque artist Caravaggio (1571–1610) used both of these narratives as an inspiration for paintings.

In the sixteenth century, the Renaissance artists were able to exploit the scientific advances in mirror making. Artisans in Murano in Venice began to produce a flat glass that could be coated with metal to produce a perfect reflective surface. The technique was so important that a governing body called the "Council of Ten" was authorized to protect the method of production. To ensure that the process was undisclosed, the glass makers themselves were kept in isolation and were forced to conceal their secrets. The technique was, however, eventually leaked to King Louis XIV of France and the monopoly was destroyed. Murano glass mirrors were extremely important for the Renaissance painters to help them create highly realistic paintings. They also enabled them to develop perspective techniques.

Leonardo da Vinci wrote about how mirrors can be used to evaluate work: "When you wish to see whether your whole picture accords with what you have portrayed from nature take a mirror and reflect the actual object in it. Compare what is reflected with your painting and carefully consider whether both likenesses of the subject correspond, particularly in regard to the mirror."

Artists have always used mirrors as a creative tool and have often used them symbolically. Velázquez, for example, painted the King and Queen of Spain within a reflected image at the very center of *Las Meninas*. Manet's *A Bar at the Folies-Bergère* portrays an enigmatic barmaid gazing directly at us, a large mirror behind her. Both artists used the mirror as a device to convey a complex layered narrative.

For this exercise you are going to study the image that is created on a convex reflective surface. You are going to study both the subject and its contorted reflection.

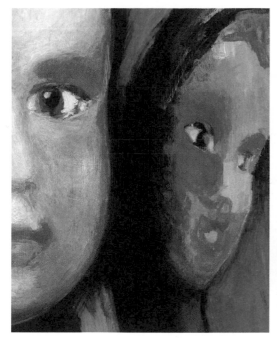

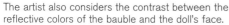
The artist also considers the contrast between the reflective colors of the bauble and the doll's face.

"I am silver and exact. I have no preconceptions.
Whatever I see I swallow immediately
Just as it is, unmisted by love or dislike.
I am not cruel, only truthful—"

Extract from "Mirror" by Sylvia Plath

Look Up

Otto Dix *Girl at the Mirror*
René Magritte *Not to be Reproduced*
Diego Velázquez *Las Meninas*
Edouard Manet *A Bar at the Folies-Bergère*
Roy Lichtenstein *Mirror*
Jan van Eyck *Portrait of Giovanni Arnolfini and his Wife*
J.M.W. Turner *Lecture Diagram: Reflections in Two Transparent Globes*
Michelangelo Merisi da Caravaggio *Medusa*
Anish Kapoor *Tall Tree and the Eye, Cloud Gate*

Method

1. Find a shiny surface—a ladle, a spoon, a festive bauble, or any object that has a shiny reflective surface and a slight curve.

2. Place your objects on a colored background (a piece of colored fabric or paper). This will help produce interesting reflected colors.

3. Position the shiny surface close to another object and look directly at its distorted reflection.

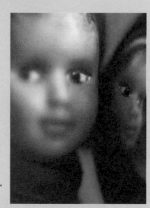
In this photograph of the artist's setup, the plastic doll is placed directly opposite the reflective bauble.

4. Choose an appropriate painting surface and begin to sketch your composition. Concentrate on the object and its reflection. With convex reflective surfaces the image will appear larger in the center. Consider the way the image mutates.

5. Pay close attention to the light, shadow, color, and tone. These will probably differ when observing the object in relation to its reflected image.

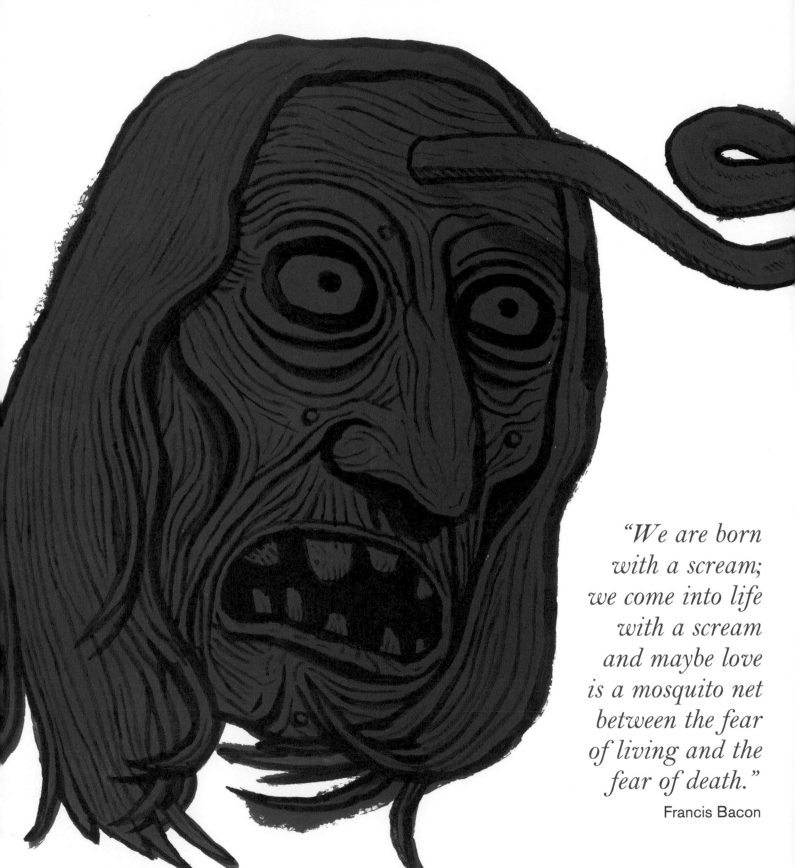

"We are born with a scream; we come into life with a scream and maybe love is a mosquito net between the fear of living and the fear of death."

Francis Bacon

The Stuff of
Nightmares

Francis Bacon's (1909–92) extreme visceral depictions of hell were for him a true representation of the absolute terror of life itself. "What horror could I make to compete with the horrors that go on every single day?"

Bacon was obsessed by Velázquez's painting *Portrait of Pope Innocent X* and, over his lifetime, made and reworked many paintings of the subject. The most well-known painting from this series is his *Study after Velázquez's Portrait of Pope Innocent X*. Bacon's nightmarish vision of the screaming Pope references a similarly screaming woman in the brutal "Odessa Steps" scene from Sergei Eisenstein's seminal film *Battleship Potemkin* from 1925. "I was absorbed by the beautiful red and purple of the interior of the mouth much like Monet was obsessed by haystacks and the light falling on them from hour to hour," he once said in reference to the painting.

Bacon's haunting, violent, and sometimes grotesque paintings are colored by the difficulties and problems that he faced in life—from his childhood experiences of being brutally punished by his father and living through two world wars, to the suicide of friends and most notably, in 1971, his lover George Dyer.

Method

1. Keep a notebook by your bed to write down all the gory details of your nightmares, while they are still fresh in your mind.

2. Later on, sift through the most visually interesting ones and then unleash these horrors onto canvas or paper.

3. Painting your nightmares can be a cathartic and sometimes therapeutic experience. The process may also help you to confront and hopefully expel your inner demons!

4. You can use your "nightmare" notebook to inspire and inform other paintings.

Look Up

Francis Bacon *Study after Velázquez's Portrait of Pope Innocent X*
Henry Fuseli *The Nightmare*
Hans Memling *Hell*
Andy Warhol *Electric Chair*
William Blake *The Ghost of a Flea*
Peter Paul Rubens *Saturn Devouring His Son*
Michelangelo Merisi da Caravaggio *Medusa*
Francisco Goya *The Sleep of Reason Produces Monsters*
Théodore Géricault *Study of Two Severed Heads*
Edvard Munch *The Death of Marat*
Pieter Brueghel *Massacre of the Innocents*

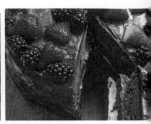

Wayne Thiebaud (b. 1920) is best known for his paintings of cakes, pies, pastries, and candy. He uses a palette knife to apply thick layers of paint to canvas, like decorating a cake with frosting; he is inspired by childhood memories of his mother's baking. In 1962, Theibaud featured alongside Roy Lichtenstein, Andy Warhol, and James Rosenquist in a highly significant *Time* magazine article entitled "The Slice of Cake School."

Have Your Cake and Paint It

Inspired by Thiebaud's work, your task will be to make a painting of a cake using a palette knife and oil paints. You will have to hold off eating the cake until you've finished the painting!

Your painting will also be made using the "alla prima" technique. *Alla prima* is an Italian term that means "at first attempt." The technique requires a painting to be started and completed in one session. It is also known as "direct" or "wet-on-wet" painting. This can be a daunting prospect, but if mistakes happen, the paint can always be scraped or wiped off.

Method

1. Bake a cake. Consider the shape and color of your cake carefully. A red velvet or a colorfully frosted cupcake is obviously more visually appealing than a plain butter cake. You can use food coloring to heighten the color of the sponge or use colored frosting. You may also choose to add texture to your cake with frosting or using various cake decorations. Don't despair if this is beyond your culinary skills; you can always buy a cake from a bakery.

2. While the cake is baking, gather some painting knives, oil paint, and canvas. Plastic painting knives are cheaper than metal ones. However, they are more brittle and have less flexibility in the blade than their metal counterparts. Plastic ones will do for now, but it's worth investing in a set of metal knives, if you later decide to continue using this technique.

3. Once the cake is baked, decorate it with frosting and other adornments. When you are happy with its appearance, place it in different lighting conditions and look at it from different angles—you might want to paint it from above or at table level. Decide whether you want to cut a slice or paint it as it stands. Study the form, texture, and shadows of the cake.

4. Next, consider the composition of your cake. To get you started you can sketch out the form with a brush, using a few quick gestural strokes. Then squeeze your paints onto the palette and mix with a trowel-shaped or flat knife. Block in colors by scooping up

the mixed color and spread it onto the canvas. Paint the darker tones first and build up the layers gradually, finishing with the lighter tones. You can use the tip of the knife for details and the edge for straight lines. The knife can also be used to scratch into the paint using the sgraffito technique (see page 24) to create interesting textures.

5. When you are totally satisfied with your painting, give in to temptation and dig in.

(see page 24)

Look Up

Wayne Thiebaud Cake paintings
Maira Kalman *Mary Lincoln's White Cake*
Claes Oldenburg *Floor Cake*
Emily Eveleth *Unintended Consequences*
Jeff Koons *Cake*

The composition is sketched out using a few quick gestural strokes.

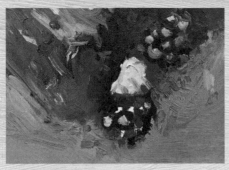

Here, the darker tones are applied and then the fruits are highlighted with lighter tones.

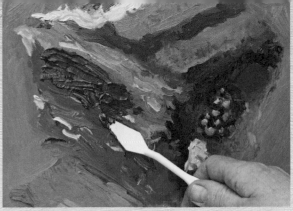

The palette knife is used to scratch into the paint using the sgraffito technique. It is also used to create lines and details.

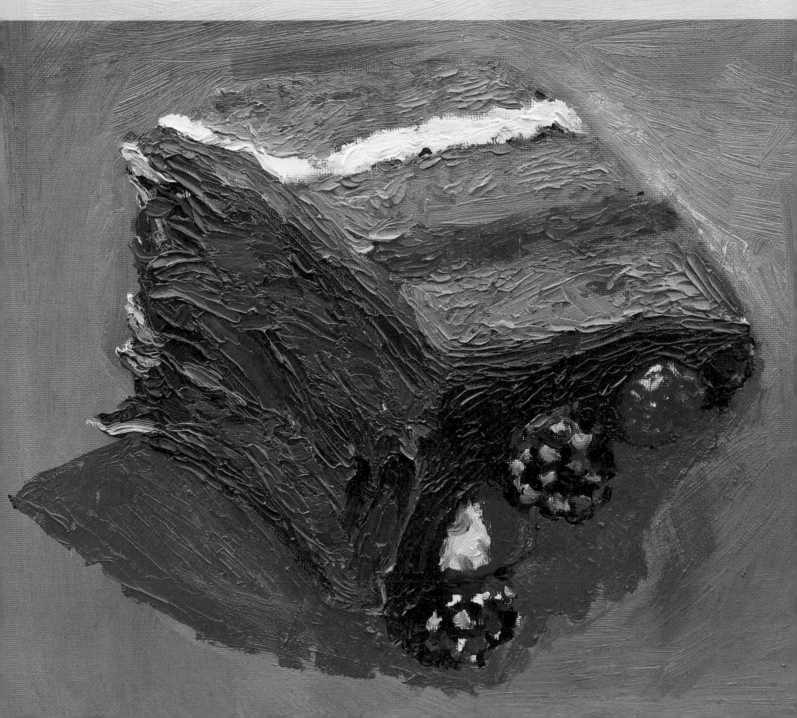

Method

1. Root around in your kitchen cupboards and refrigerator to find different foods to paint with. You can paint with either one material or a combination.

2. You can use a palette knife for thick, pastelike substances such as peanut butter. You can use brushes to paint with less viscous substances. However, don't use your best brushes for this exercise.

3. Paint onto thick oil and acrylic paper—oily substances will bleed on other kinds of paper.

4. Consider the strengths and limitations of your material. Now draw your design onto the paper with a pencil, and then begin.

Why do we have to use conventional materials to paint with? Painting is a highly subjective experience and we alone can decide where the boundaries are in terms of material and content.

Painting without Paint

Many artists have used unconventional materials to create paintings. Vik Muniz (b. 1961) is a Brazilian artist who often uses materials that he feels are appropriate to his subject. He has made work with substances such as thread, chocolate syrup, garbage, string, wire, and sugar. While traveling to the Caribbean island of Saint Kitts he encountered children working on sugarcane plantations. "Sugar Children" is a series of portraits created from sugar, to highlight the plight of these children. "All the sweetness from them ends up in our coffee. So I made drawings of them from sugar."

Here we are going to push those boundaries and explore alternative methods of imagining a painting.

Tomato ketchup — Coffee — Chocolate — Chili oil — Soy sauce — Raspberry sauce — Peanut butter — Black pepper — Pesto

Look Up

Vik Muniz *Valentine, The Fastest*
DJ Simpson *No Above And No Below*
Damien Hirst *Symphony In White Major Absolution II*
Boyle Family *Earth Studies*
Dan Colen *Chewing Gum on Canvas*
Chris Ofili *The Holy Virgin Mary*
Julian Schnabel *Dennis Hopper*
Henry Krokatsis *Quicksand*

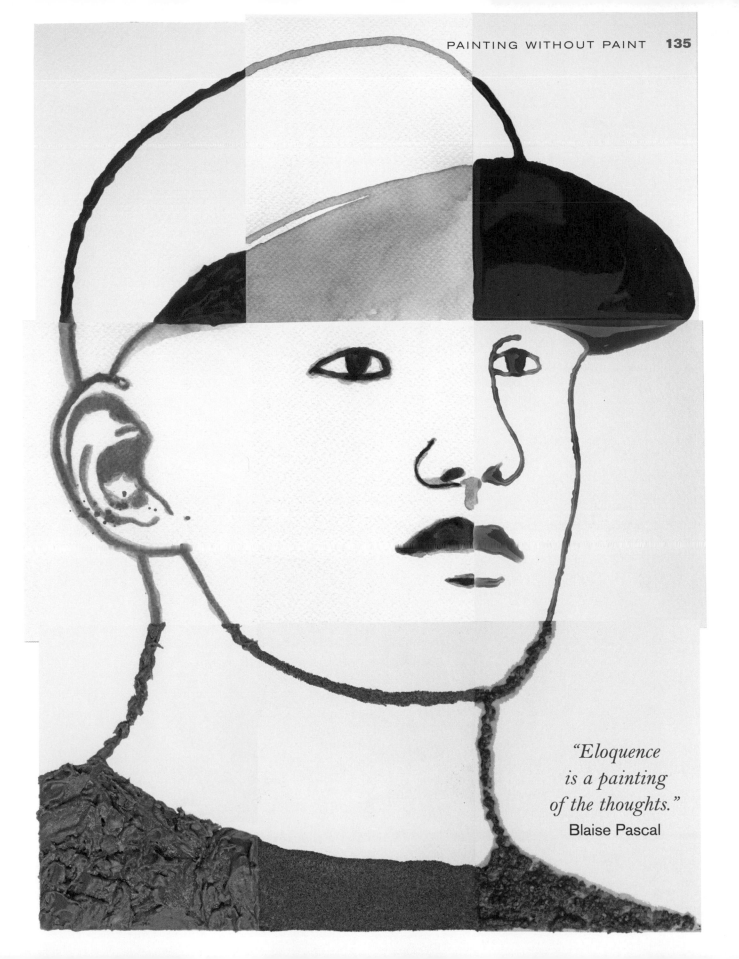

*"Eloquence
is a painting
of the thoughts."*
Blaise Pascal

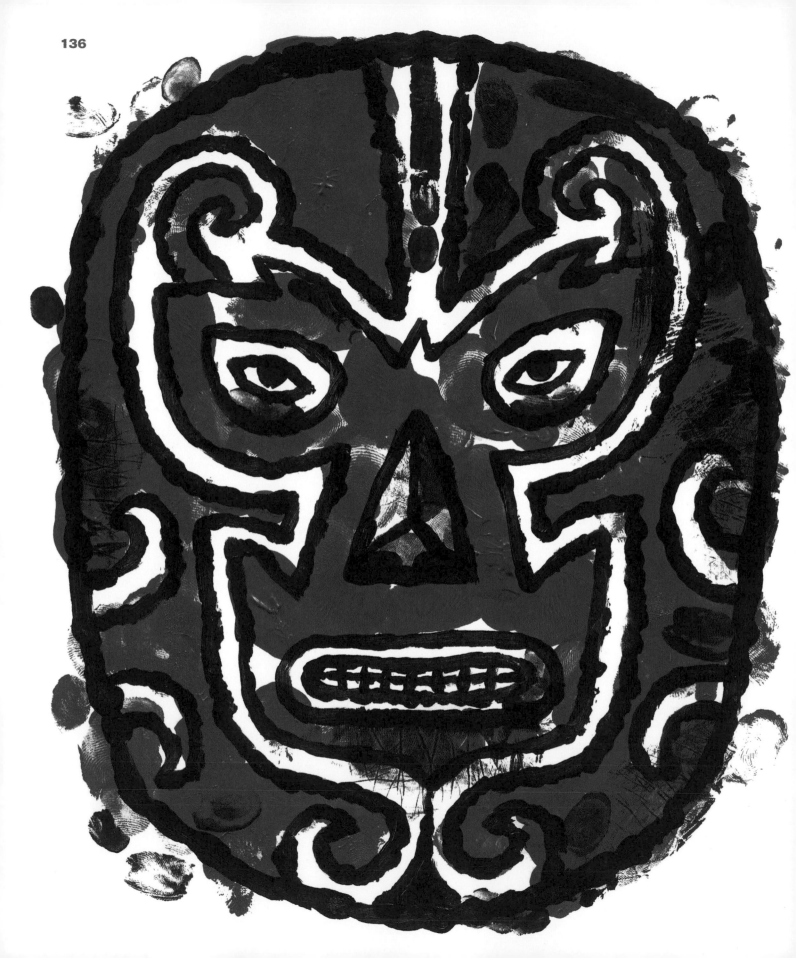

Gao Qipei (1660–1734) was the most celebrated artist of the Qing Dynasty. He wasn't content with painting in the traditional style and wanted to push the boundaries of his art. His search to find a unique painting style eventually came to him in a dream, and he abandoned brushes in favor of painting with his fingers. He grew an extra-long fingernail which was split at the top like a dip pen, to paint fine details, and he used the palm of his hand to apply washes. The fluidity and spontaneity of his line made his paintings stand out from those of his contemporaries.

Lift a Finger

In 1985 the American artist Chuck Close adopted finger painting to make a photorealistic painting of his wife's late grandmother, titled *Fanny/Fingerpainting*. He used his fingerprints to apply oil paint, varying the pressure he placed on the canvas to create tonal shifts. His large-scale portrait is incredibly detailed, and it's only on closer inspection that his finger-printing process is revealed.

This exercise is not about swiping your finger on a computer tablet to make digital paintings. It's about getting your fingers dirty and reliving those childhood experiences of joyfully creating messy paintings. Delighting in the tactile quality of paint is not only therapeutic, but is also a great way to learn about and explore the medium.

Use nontoxic paints on paper. It is best to find natural or organic paint that will not irritate your skin. If in doubt, some manufacturers produce paint that is specifically geared toward the preschool finger painter.

The American folk artist Jimmie Lee Sudduth (1910–2007) mixed his own finger paints by blending natural substances such as mud, soot, chalk, and rocks that he collected from his rural surroundings. To create a palette of colors, he mixed extracts from leaves, grasses, and berries. Sudduth used his fingers and hands to apply the paint to wooden boards to make "mud pictures."

Methods

1. Use the tips of your fingers to make prints.

2. You can also use other areas of your hand to paint with. The "karate chop" stroke can be used to block in bigger areas, as can the palm of your hand.

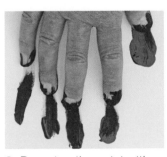

3. Dragging the paint with your fingers can create dramatic effects.

"Brushes wear out and my fingers don't. When I die, the brush dies too."
Jimmie Lee Sudduth

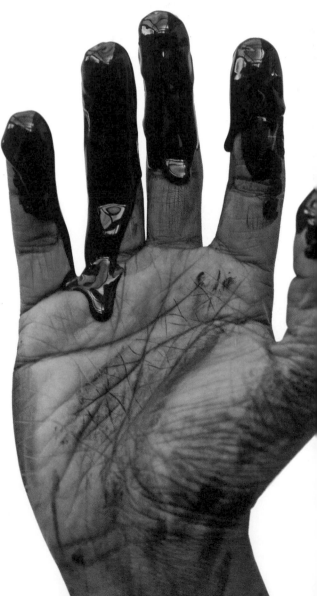

1

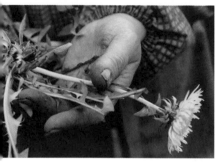

2

Method

1. Go out and find yourself a forgotten and neglected weed.

2. Gently pull it up and shake the excess dirt from the roots.

3. Begin to sketch out the delicate leaves and root system in a light pencil, on watercolor paper. Look at the contrasting tones and colors of the plant.

4. The stem, leaves, and flowers will be completely different. Begin to paint in the color. Paint the contrasts that you see. Use opaque paint or dilute it to give a more transparent effect.

5. Fill the page with the design, extending out in all directions.

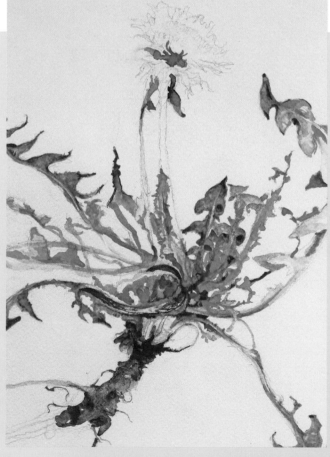

3

Weed Control

The term "weed" is used subjectively to describe a plant that is unwanted. Common weeds can therefore be discovered flourishing in untidy forgotten corners, breaking through the cracks of sidewalks, and creeping up walls. They are abundant and yet often ignored, left alone to germinate with impunity.

In 1503, Renaissance artist Albrecht Dürer (1471–1528) painted a radical watercolor, *The Large Piece of Turf*. The painting is an almost scientific study that depicts a meadow, overgrown with weeds, leaves, blades of grass, and dandelions. At this time it was seen as an extremely progressive idea to glorify a small piece of the natural world as opposed to the divine world. Dürer proclaimed: "I realized that it was much better to insist on the genuine forms of nature, for simplicity is the greatest adornment of art."

The British artist Michael Landy (b. 1963) made a body of work exploring the humble weed. He decided to cultivate

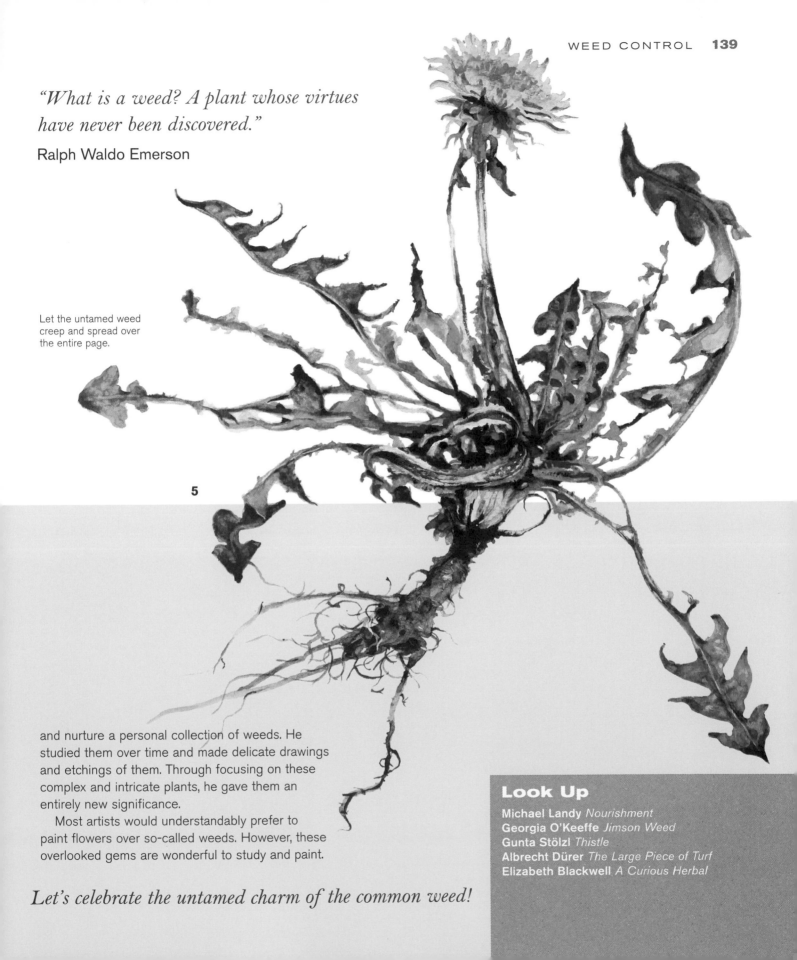

"What is a weed? A plant whose virtues have never been discovered."

Ralph Waldo Emerson

Let the untamed weed creep and spread over the entire page.

5

and nurture a personal collection of weeds. He studied them over time and made delicate drawings and etchings of them. Through focusing on these complex and intricate plants, he gave them an entirely new significance.

Most artists would understandably prefer to paint flowers over so-called weeds. However, these overlooked gems are wonderful to study and paint.

Let's celebrate the untamed charm of the common weed!

Look Up

Michael Landy *Nourishment*
Georgia O'Keeffe *Jimson Weed*
Gunta Stölzl *Thistle*
Albrecht Dürer *The Large Piece of Turf*
Elizabeth Blackwell *A Curious Herbal*

"O would some power the gift to give us, to see ourselves as others see us."
Robert Burns

It is widely acknowledged that the greatest self-portraitist was Rembrandt van Rijn (1606–69). Over a period of 40 years he painted approximately 40 to 50 self-portraits. These paintings display a range of techniques and facial expressions, and all are examples of Rembrandt's constant desire to self-examine and self-reflect. From the age of 22, right through to his death at 63, he produced an extraordinary series of penetrating images, describing the emotional progression of his complex and tumultuous life.

Looking at Me?

Painting a self-portrait can be a great way to experiment and develop your skills without the pressure of pleasing the sitter. As the painter John Singer Sargent (1856–1925) famously said, "Every time I paint a portrait I lose a friend." Apart from the convenience of painting yourself, it's also a great way to practice painting various moods and expressions.

Your task is to paint an honest self-portrait. We are often very critical about the way we look, and painting a self-portrait can sometimes be an exercise in retouching all the imperfections! It doesn't have to be a warts-and-all depiction, but try to avoid making a painting that doesn't bear any likeness to you. It's not just about capturing a realistic likeness; a good self-portrait should also try to capture the spirit of the artist.

You can choose either oil or acrylic paints for this exercise. There are pros and cons to using either medium. Many feel that oils are the natural choice for portraiture, as the medium allows for smooth and subtle blending; however, the quicker drying time of acrylics can give you more immediate results. This does mean, though, that even with the use of a retarding agent, acrylics give you less time to blend tones. Also, the binder used in acrylics means that your painting will dry a little darker than when the paint was first applied.

See Also:
On Reflection, pages 128–129

A wash of diluted Burnt Sienna acrylic was painted onto canvas board, then the face was sketched with a round brush and some thicker Burnt Sienna paint.

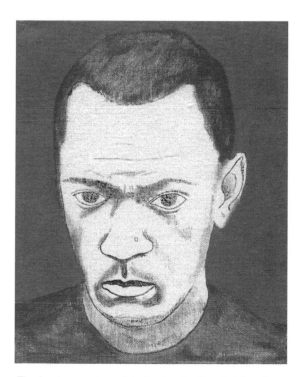

The background was blocked out with a flat brush and gray paint.

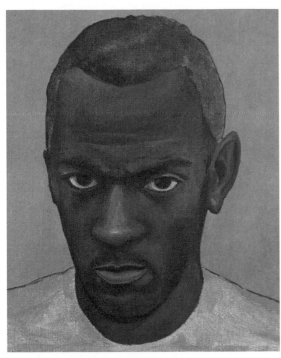

The skin tone was initially blocked out with a flat brush and a mix of Burnt Sienna, Burnt Umber, and Yellow Ocher. The shadow areas were then marked out with a mix of Burnt Umber and Bone Black. The color values aren't in sharp contrast to each other, as the light falls gently on the face without any pronounced dark shadows.

Finally, the tattoo and other details were added with a fine brush.

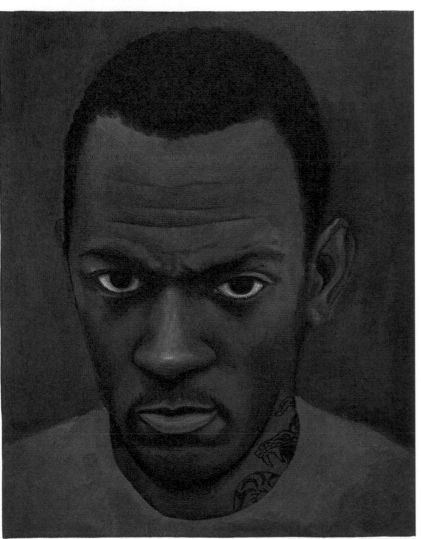

Method

1. Set up a mirror that you can sit comfortably in front of. You will just be painting your face for this exercise, so a small mirror will do. Position a canvas (no smaller than letter paper size) on an easel in close proximity to you, so that you can work directly onto it and still see your reflection clearly in the mirror.

2. Think about how to convey your character and soul through your choice of color, texture, and background.

3. Plan the way you want to light your face. Lighting can set the mood for your painting—for example, a face lit from above can be made to look incredibly menacing by creating pools of dark shadows under the eyes. Light can highlight the natural contours and contrasts of your face.

Natural light will restrict the time that you are able to paint, but will light your face in a softer and more subtle way than artificial light. However, using artificial light will give you more control over how your face is lit.

Look Up

Rembrandt van Rijn *Self-portrait with Two Circles*
Stanley Spencer *Self-portraits*
Peter Blake *Self-portrait with Badges*
Otto Dix *Self-portrait*
Gwen John *Self-portrait*
Lucian Freud *Self-portrait with Black Eye*
Pablo Picasso *Self-portrait*

It Takes Two

In the late 1970s, Jean-Michel Basquiat (1960–88) began as a street artist collaborating alongside a fellow high-school friend, Al Diaz. Together, they spray-painted graffiti on the walls of Manhattan, using the collective tag, SAMO©, which originally stood for "Same Old Shit."

Basquiat eventually accessed the conventional art world through the New York music and club scene and soon became an important element of the art scene. In 1984 he began his most famous collaboration of all, with Andy Warhol. They joined forces on a series of paintings between 1983 and 1985. As Warhol's studio assistant, Ronny Cutrone, put it: "It was like some crazy art-world marriage and they were the odd couple." *General Electric with Waiter* was one of the paintings that evolved from the partnership. Created using a variety of methods, both Basquiat and Warhol adopted a combination of techniques including hand painting and silkscreen printing.

Method

Work with another painter to create a painting. The process of painting can sometimes be a lonely experience, and this exercise will force you to paint in a less blinded way, forcing you to take on board another's thoughts and become less obsessed about your own work. There are many ways of making a joint painting—one artist can start a painting and then pass the brush to the other artist to complete it. This is how the example painting was created: The second artist responded to the first artist's contribution. Their contrasting styles and approaches made for a more interesting painting. Another approach is to work together on the same canvas at the same time, weaving in and out of each other. Although this is a more spontaneous and fun approach, it can end up like playing a game of Twister!

Look Up

Blinky Palermo and Gerhard Richter *Teflon*
Luis Buñuel and Salvador Dalí *Un Chien Andalou*
Matthew Barney and Björk *Drawing Restraint 9* (see right)
Jean-Michel Basquiat, Andy Warhol, and Francesco Clemente *Alba's Breakfast*
Jean-Michel Basquiat and Andy Warhol *General Electric with Waiter*

The first artist's representational painting (left) contrasts with the colorful patterns of the second (below). The exuberant ribbons of color also work as a counterpoint to the static image of the car.

"Painting is just another way of keeping a diary."

Pablo Picasso

In 1944, the Mexican artist Frida Kahlo (1907–54) began to compile a visual documentary of her life experiences, combining watercolor paintings, self-portraits, sketches, and poems. Her highly personal journal not only throws light on her volatile relationship with her husband, the painter Diego Rivera, but also gives us a fascinating insight into her unique creative process.

Diary of an Artist

A visual diary can be a private space in which to express your thoughts and emotions; a book in which there are no rules, where you can paint whatever you want, without feeling inhibited or self-conscious. You can use visual codes to hide the identity of people and use abstract compositions to describe your innermost feelings. Your diary can be your confidant and it will be interesting to look back on in years to come. Not only will it be a sequential record of your year, but also a place to experiment and hone your technical skills.

Method

1. Visit a well-stocked art store and take your time to decide which sketchbook will convert well into a diary. It will ideally be a book no bigger than letter paper size, with 135lb paper that is good for painting on. It might be difficult to find a book with at least 365 pages in that paper weight (not that you have to make a painting a day, but it gives you the option). If not, you can use a book for each month or quarter-year.

2. If you can't find anything suitable, buy some watercolor paper and make a book to suit your own needs.

3. You can use a watercolor travel set with dried pan paints, which is practical and easily transportable. J.M.W. Turner carried a portable watercolor case which he used on his travels. He would often add color to his artwork on his return, after sketching outside. However, you can put time aside in the evening, to review the day and use other less portable paints.

4. Your diary will be a very rewarding experience, if you have the self-discipline to keep going with it.

The images represent a visual recording of moments in time. Each in some way reflects the artist's life. Whether memories of foreign travel, a portrait of a friend, or an emotional outpouring, the sketches are personal accounts of everyday experiences.

Look Up

Frida Kahlo *The Diary of Frida Kahlo, An Intimate Self-portrait*
Pablo Picasso *Je Suis Le Cahier*
Maira Kalman *The Principles of Uncertainty, And the Pursuit of Happiness*
J.M.W. Turner Watercolors, sketchbooks
David Hockney *Fifteen Sketchbooks* (DVD), *A Yorkshire Sketchbook* (book)
Marc Chagall Sketchbooks, 1940s–60s
Henry Moore *Shelter Sketchbook*
Peter Beard *The Gardeners of Eden*

Bon voyage CHLOE

Keep a visual record of your everyday life experiences.

The sea can be a formidable force. A stormy sea can be destructive and cruel. On a calm day, however, the sea can appear tranquil and serene; the soothing ebb and flow of the waves has the power to hypnotize and draw us into a contemplative state.

Time and Tide

The British painter L.S. Lowry (1887–1976) is best known for his paintings of busy industrial scenes. However, he was also completely fascinated by the sea. He repeatedly returned to the subject, painting minimalist seascapes of the North Sea that reveal a solitary and timeless tranquility. He wrote of its compelling and mesmerizing charm: "It's all there. It's all in the sea. The battle of life is there. And fate. And the inevitability of it all. And the purpose."

With this exercise you are going to make a study of a gentle seascape. You are going to study its surface texture, and describe the surface ripples and undulations in paint.

Method

1. Choose a day when the weather is relatively calm, and take a trip to the sea or ocean.

2. Take along an acrylic pad or a canvas board and a selection of acrylic paints and brushes.

3. Contemplate the vast and boundless seascape before you. You can create a feeling of space and depth through the angle of your viewpoint.

4. Fill the picture plane with darker tones to describe the subtleties of the ocean. The color of the sea varies according to a number of factors. It is affected by the absorption and scattering of white light, the actual depth of the ocean, and the number of mineral particles within it. The color alters as it reflects the color of the sky.

5. Wait for the background layer to dry. Mix a lighter tone and begin to describe the furrows and wrinkles of the water's surface.

6. Pick out the details by highlighting the shimmering surface texture with light tones.

7. Once you have completed this study, return to the sea in different weather conditions and notice how it has undergone a "sea change." Compare and reconsider the colors, tones, and wave patterns, and paint it afresh.

Look Up

Roy Lichtenstein *Seascape 1*
Gerhard Richter *Cloudy*
Maggi Hambling *Winter Wave Crashing* ("North Sea" series)
J.M.W. Turner *Three Seascapes*
Hiroshi Sugimoto *Ligurian Sea, Saviore*
L.S. Lowry *The Sea*
Winslow Homer *Summer Squall*
Gustave Courbet *Seascape*

The artist has chosen a calm day (on the Atlantic Ocean); the sky is slightly overcast. For the undercoat, they have used a combination of Burnt Umber, Sap Green, Cobalt Turquoise, Ultramarine Blue, and Payne's Gray blended together across the gesso-primed canvas board.

Palette

Burnt Umber

Sap Green

Cobalt Turquoise

Ultramarine Blue

Payne's Gray

Titanium White

A mixture of Sap Green, Cobalt Turquoise, and Titanium White is applied in small sweeping strokes to map out the wave patterns.

The wave patterns now completely cover the canvas. The artist begins to accentuate the darker tones with an opaque Burnt Umber and Sap Green. In certain areas they have applied a transparent wash to soften the waves.

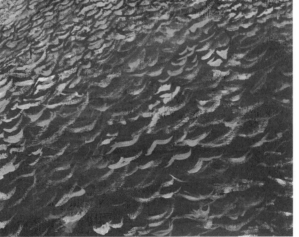

Finally the surface texture is emphasized with Titanium White to highlight the reflected glints.

*"Consider the subtleness of the sea;
how its most dreaded creatures glide
under water, unapparent for the most
part, and treacherously hidden
beneath the loveliest tints of azure."*

Herman Melville, *Moby-Dick*

"Snow provokes responses that reach right back to childhood."
Andy Goldsworthy

Let it Snow

Do you remember the childhood excitement of waking up to a snow-covered landscape on a winter's day? Unfortunately, this excitement dissipates as we get older, and snow is viewed as an inconvenience. The days of snow angels, having snowball fights, and sledding are a long-distant memory.

Well it's time to get excited again! Don't view the snow with dread—think of the beautiful white blanket as a perfect canvas for your art.

Method

1. Make some sketches of your proposed design indoors, before you head out into the cold. A design that is simple and graphic will work best.

2. Fill up a number of squeezy-type bottles with a variety of diluted colors. You can use any water-based paint or even food coloring. However, don't dilute the paint too much, as it will drip everywhere.

3. Dress appropriately—it's no fun painting when your fingers and toes are numb with cold!

Look Up

Andy Goldsworthy
*Snow Sculpture,
Snow Circles, Slits
Cut Into Frozen Snow,
Snow Shadow*
Yücel Dönmez
Snow painting in the Hınıs
Gorges of Erzurum's
Palandöken Mountains,
Turkey; Snow painting in
Chicago Grand Park
(Millennium Park)
Helen Chadwick
Piss Flowers

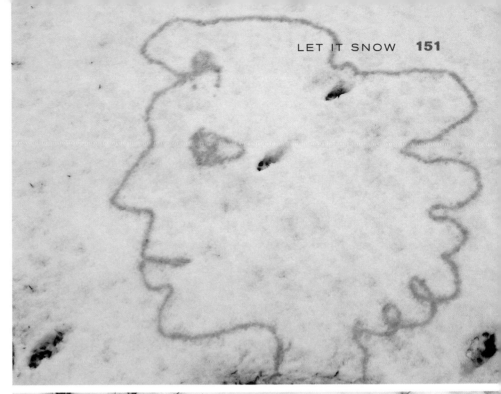

4. Now head out and find a clean patch of snow. A field or park will give you a bigger canvas to make as many paintings as you want.

5. Squeeze the bottles to make your mark. You might want a practice run first, before you embark on your final piece. However, these paintings are transient, so you don't have to be incredibly meticulous about things.

6. You can manipulate the quality of line by the distance you hold the bottle from the ground. Holding the bottle close to the snow will give you a finer line. Drips and splashes can be used to enhance a design.

7. The paint will slowly bleed into the wet snow and the colors will quickly become less saturated.

8. Inevitably, the snow eventually melts away and your creation is lost forever.

9. Take photographs of your creations as a keepsake. The artist Andy Goldsworthy records his works in snow photographically and the prints of his creations are then exhibited.

See Also:
Float On,
pages 20–21

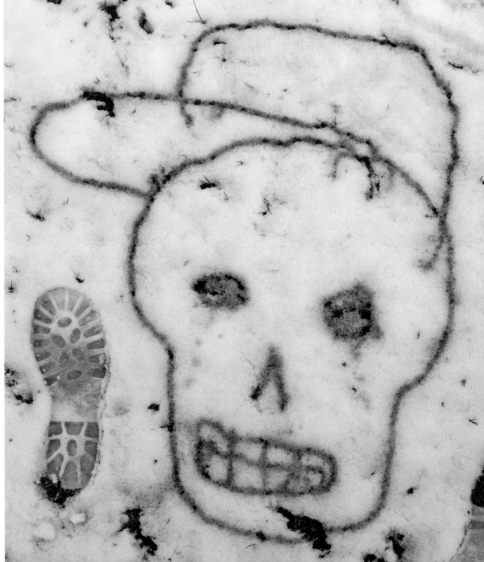

"For me, the camera is a sketchbook, an instrument of intuition and spontaneity."
Henri Cartier-Bresson

Picture This

Painters throughout history have been fascinated by photography and have used it to enhance their paintings.

It is widely thought that the Venetian artist Canaletto (1697–1768) used a camera obscura as a drawing aid. The camera obscura is the precursor to photography. It is a box or a room that has a hole on one side which light passes through to project an upside-down image of the outside world on the inside.

Edgar Degas was another artist who used cameras as an aid to make some of his paintings. He is best known as one of the leading lights of the Impressionist movement, but was also an avid photographer. He used some of his photographs as preparatory studies for his paintings, but most were taken for pleasure and as a way of expressing his ideas with another medium. Many other artists, such as Toulouse Lautrec, Man Ray, and Pablo Picasso used photography as a means to enrich and inform their work. They realized its potential as a visual aid and were inspired by its immediacy and "realistic" accuracy.

So, put your brush down and step away from your paints. This exercise is about observation and there will be no painting involved. However, you will still be required to do some work, so have a camera at hand. Look around you and find "pictures" in your everyday environment. Photograph the textures, patterns, and colors that you find inspiring. Compose your pictures as you would if they were paintings. Make a habit of taking pictures wherever you go—there's no excuse not to; you can use the camera on your phone. Build an archive of photographs that can be used as an aide-mémoire. You can then make a Flickr account to compile your photos or simply keep them stored on your computer. Alternatively, you may want to print them out and stick them in a scrapbook.

Depending on how organized you are, you can file them under different categories (abstract, people, landscapes, etc). You can then use this reservoir of images to stimulate your imagination and inform your paintings.

Look Up

Gerhard Richter *Abstraktes Bild*
Antoni Tàpies *Gray Relief on Black* from "Matter Paintings" series
Robert Rauschenberg *Charlene*
Julian Schnabel *Oar: For the One who Comes Out to Know Fear*
Boyle Family *World Series*

See Also:
Overpainting,
pages 92–93

Doodling happens spontaneously and is associated with drawing rather than painting. The practice of painting is seen as more formal than drawing. Preparatory drawings and sketches are often the prelude to a painting.

Doodle Painting

The practicalities of doodling with a paintbrush are obviously more limiting than with a pen—for example, it is much easier to have a pen in hand in a boring meeting or during a long telephone conversation. But why should drawing have all the fun?!

A blank canvas can be quite a daunting prospect, and doodling with a paintbrush can be a way of loosening up and unlocking your creativity. The very nature of doodles is that they are private and so this will inevitably give you the freedom to express unconscious thoughts and also stimulate your creativity.

Method

1. Ditch your pens and pencils, and start doodling with a brush and paints. Keep a primed canvas or board nearby, to doodle on with fast-drying paints—the spontaneity of doodling won't work with oil paints that take forever to dry.

2. Don't be too meticulous about your doodle paintings—paint over or around previous images, building layers of doodles.

Look Up

Trenton Doyle Hancock
 No Gas: My First Italian Trip
Joan Miró *Carnaval de Arlequin*
Tal R *Lords of Kolbojnik*
Keith Tyson *Large Field Array*
Jean Dubuffet *La Ronde des Images*

Glossary

Abstract art
Type of art in which the artist relies on color and form instead of choosing to portray the subject in a realistic or naturalistic way.

Abstraction
Reduction or simplification of an image or object to an essential aspect of its form or content.

Achromatic color
Any color that is without chromatic content. Black, white, and shades of gray are achromatic colors.

Acrylic paint
A fast-drying paint containing acrylic polymer emulsion.

The Bezold Effect
An optical illusion, named after a German professor of meteorology, Wilhelm von Bezold.

Binder
A liquid substance that holds together dry pigment.

Blending
A gentle and gradual gradation of paint from one color into another.

Blocking in
Initial application of mass of medium representing the division of area into a value pattern.

Bodegón
Derived from a Spanish term *bodega*, meaning "pantry" or "wine cellar." Referring to the everyday objects depicted; often a collection of foods or kitchen utensils placed on a stone slab.

Cast shadow
The shadow thrown by a form onto an adjacent or nearby surface in a direction away from the light source.

Chiaroscuro
An Italian word (meaning "light-dark") referring to the modeling of volume by depicting light and shade by contrasting them boldly. This is one means of strengthening an illusion of depth on a two-dimensional surface, and was an important topic among artists of the Renaissance.

Chromatic color
The saturation of a color. Examples of chromatic colors are blue, green, red, and so on.

Collage
Technique of forming a picture by pasting any suitable materials (pieces of paper, photos, news cuttings, fabrics) onto a flat surface.

Color beginnings
The spontaneous, experimental watercolor studies of J.M.W. Turner.

Color wheel
A combination of colors formed in the shape of a circle.

Combing
To drag a comb, or other tool with teeth, across wet paint.

Composition
The arrangement and combination of elements in a picture.

Contrails
White lines that you see in the sky that are water vapor trails emitted from the exhausts of airplanes.

Cropping
The cutting out or exclusion of extraneous parts of an image to show only the portion desired or to fit a given space requirement.

Crosshatching
Technique for building up areas of shadow with layers of criss-cross lines instead of solid tone.

Cubism
Art style developed in 1908 by Picasso and Braque whereby the artist breaks down natural forms into geometric shapes and creates a new kind of pictorial space. Unlike traditional styles, where the perspective is fixed and complete, Cubist works portray a subject from multiple perspectives.

Denman Ross Scale
A nine-step, tonal value scale (black and white).

En plein air
A French term meaning "in the fresh air."

Expressionism
Art movement of the early twentieth century in which adherence to realism and proportion was replaced by the artist's emotional connection to the subject. These paintings are often abstract, the subject distorted in color and form to emphasize and express the intense emotion of the artist.

Focal point
An area or element that dominates a drawing; the area to which the viewer's eye is most compellingly drawn.

Form
The volume and shape of a three-dimensional work.

Form shadow
The less defined, dark side of an object. Usually the side that is not facing the light source.

Gesso
A primer that dries with a matte finish.

Glaze
A term used in oil painting to describe the process by which a thin layer of transparent medium is painted over the surface of a painting.

Golden section
System of organizing the geometrical proportions of a composition to create a harmonious effect. Known since ancient times, it is defined as a line divided in such a way that the smaller part is to the larger part what the larger part is to the whole.

Gouache paint
A water-soluble paint that is often applied as an opaque, rather than transparent color.

Graduation
Gradual progression of tones, from dark to light or light to dark.

Granulation
A textured appearance in a watercolor wash.

Gutta
A resistant substance extracted from the Indonesian rubber tree, Gutta percha. Gutta can be painted or drawn onto fabric, and will create a barrier to keep the paint from running or merging into other colors.

Hatching
Shading technique of using parallel lines to indicate form, tone, or shadow.

Highlights
Identifies the brightest areas of a form where light bounces off its surface. Usually the area closest to the light source.

Horizon line
Imaginary line that stretches from the point from which the painting is viewed at eye level, to the location of the vanishing point or points. The horizon line in perspective should not be confused with the line where the land meets the sky, which may be considerably higher or lower than your eye level.

Hue
A color, including red, green, blue, yellow, and orange etc. Different hues have different wavelengths in the color spectrum.

Impasto
An Italian term that refers to the application of thick layers of paint onto a surface.

Impressionism
Late-nineteenth-century French style that opted for a naturalistic approach using broken color to depict the atmospheric and transforming effects of light. It is characterized by short brushstrokes ot bright colors that recreate visual impressions of the subject and capture the light, climate, and atmosphere at a specific moment.

India ink
A simple black ink commonly used for drawing that was once widely used for writing and printing.

Luminosity
A measurement of brightness.

Masking out
Covering up areas with masking tape, masking fluid, or any other barrier to resist paint. The image can then be left clear or worked over.

Medium
Type of material one works with, such as acrylic, watercolor, gouache, etc.

Mixed-media
Technique of using two or more established media in the same picture.

Monochrome
Of one color, chroma, or hue.

Negative space
Painting the space around an object rather than the object itself.

Oil paint
Paint made with natural oils such as linseed, walnut, or poppy, as the medium to bind the pigments.

Overspray
Paint that escapes over the edges of the spray-paint template.

Pigment
Raw substance of color. Each pigment has its own origin, be it an earth mineral or organic substance. Paint is made from pigment mixed with a medium.

Pointillism
Technique of applying color in dots rather than in strokes or flat areas. Developed by Georges Seurat, this technique is sometimes called Divisionism or Neo-Impressionism.

Portrait
An up-close study of a person, animal, or flower. Implies a degree or accuracy and formality.

Primary color
Red, yellow, and blue. All colors are a combination of these three hues.

Proportion
The compositional relationship between parts.

Rule of thirds
Division of an area by thirds, vertically and horizontally. To place your center of interest at any one of the four intersections is considered to be advantageous.

Sgraffito
An Italian word meaning "to scratch."

Scratching
Scratching into wet paint with a sharp tool.

Scumbling
An undercoat of paint with the application of a thin coat of a lighter color over the top. This gives a softening effect.

Secondary color
Created by mixing the three primary colors of red, yellow, and blue. Secondary colors are made by mixing primary colors. Green is a secondary color created by mixing yellow and blue. Orange is a mixture of red and yellow. Violet is a mixture of blue and red.

Shading
The process of adding tone to a painting so as to create the illusion of texture, form, and three-dimensional space.

Still life
Piece of art featuring an arrangement of inanimate objects. Traditionally objects were selected for their symbolic meanings.

Stippling
Pattern of dots created with dry paintbrush bristles dipped into paint and applied perpendicularly to the page in an up-and-down motion.

Stretching paper
Paper is often soaked and stretched before being worked on to remove surface impurities and make it more receptive to your brushstrokes. A rough guide is to soak the paper in lukewarm water in a tub large enough to hold the sheet for five minutes, and then tape or staple it to a stretching board.

Surrealism
Developed in 1920s Europe, a style of art characterized by the use of the subconscious as a source of creativity to liberate pictorial subjects and ideas. Surrealist artists often depict unexpected or irrational objects in an atmosphere of fantasy, creating a dreamlike scenario.

Tone
Also known as value, the lightness or darkness of any area of the subject, regardless of its color. Tone is only related to color in that some hues are naturally lighter than others. Yellow is always light in tone whereas purple is always dark.

Suminagashi
A Japanese term meaning "floating ink."

Tertiary color
A tertiary color is a color created by mixing a primary and a secondary color.

Underpainting
The background area of paint that is applied before the details are painted.

Underdrip
Where the spray paint bleeds under the stencil template.

Value
A measurement of the brightness of a color. The brighter the color, the higher its value.

Viscosity
The thickness and consistency of paint.

Wax resist
Wax is applied to a surface and a watercolor wash is painted over the wax. Where the wax is applied, the paint is repelled and absorbed around it.

Watercolor paint
A water-soluble pigment.

Wet-on-Wet
Wet paint applied to a previous layer of wet paint.

Yu pi yo mo
A Chinese term meaning "to have brush, to have ink."

Websites
www.artforum.com
www.beautifuldecay.com
www.frieze.com
www.juxtapoz.com
www.merzbarn.net
www.moma.org
www.saatchigallery.com
www.tate.org.uk
www.walkerart.org

Books
Vitamin P, Barry Schwabsky
Chroma, Derek Jarman
The Shock of the New: Art and the Century of Change, Robert Hughes
On Painting, Leon Battista Alberti
The Art of Color: The Subjective Experience and Objective Rationale of Color, Johannes Itten
Painting Today, Tony Godfrey
The Artist's Handbook of Materials and Techniques, Ralph Mayer
What Painting Is, James Elkins
This is Modern Art, Matthew Collings
Beautiful Losers: Contemporary Art and Street Culture, Aaron Rose, Christian Strike, Alex Baker, Arty Nelson & Jocko Weyland
Color: A Course in Mastering the Art of Mixing Colors, Betty Edwards
Interaction of Color, Josef Albers

Kandinsky's Questionnaire Results (see page 54)
Triangle = Yellow
Square = Red
Circle = Blue

Index

Credits

Alamy, p.142
Alybaba, Shutterstock, pp.122tcr, 123tcl
Anatolyevitch, Ustyuzhanin Andrey, p.122tcl
Belobaba, Shutterstock, p.123tl
Bristow, Louise, www.louisebristow.com, Photography by Bernard G Mills, pp.124–125
Clinch, Moira, pp.74–75, 116b, 120–121
Corbis, p.117tr
Dumas, Marlene, *Suikerspook* (1996). Watercolor on paper. Rabo Art Collection, photography by Peter Cox, p.94
Faljyan, Karen, Shutterstock, p.122tr
Goicolea, Anthony p.78bl
Higgins, Nick, www.nickhiggins.co.uk, pp.87–89
iStock, p.22tl
Nash, Paul, Getty Images, pp.46–47
Rafal Fabrykiewicz, Shutterstock, p.123tr
Rex Features, pp.116–117t
Tang, Dora, Shutterstock, p.122tl
Wildnerdpix, Shutterstock, p.123tcr
Wilson, Ben, Rex Features, p.44bl

All other illustrations and photographs are the copyright of Sam Piyasena and Beverly Philp or Quarto Publishing plc. While every effort has been made to credit contributors, Quarto would like to apologize should there have been any omissions or errors—and would be pleased to make the appropriate correction for future editions of the book.

Quarto and the authors would like to thank the following paint manufacturers whose paints are used throughout this book:

Acrylics: Golden Artist Colors Inc.; www.goldenpaints.com; email: goldenart@goldenpaints.com
Watercolor: M Graham & Co.; www.mgraham.com
Oils: Michael Harding; www.michaelharding.co.uk; email: oilpaint@michealharding.co.uk
Gouache: Schmincke; www.schmincke.de; email: info@schmincke.de

Beverly Philp
Many thanks to my parents and family for their support and to Suki for her patience and encouragement.

Sam Piyasena
A special thanks to Dad and Mum for all your encouragement and support. Many thanks to Sandy, Vas, Sophie, Sonny, and Harry. A big thanks to Suki for your sense of humor, love, and patience. Looking forward to reading your book when it's published!

We would both like to thank Moira, Ruth, Karin, Kate, Paul, Caroline, and all at Quarto who worked on the book. Many thanks to our friends Nick and Louise for the use of their wonderful work. Finally, a big thank you to our friend Richard Combes for all his brilliant advice.